JANUARY

	THURS	FRI	SAT
	1	2	3
	8	9	10
4	15	16	17
1	22	23	24
8	29	30	31

LAPD '53

JAMES ELLROY

» AND «

GLYNN MARTIN

LOS ANGELES POLICE MUSEUM, EXECUTIVE DIRECTOR

Abrams Image

New York

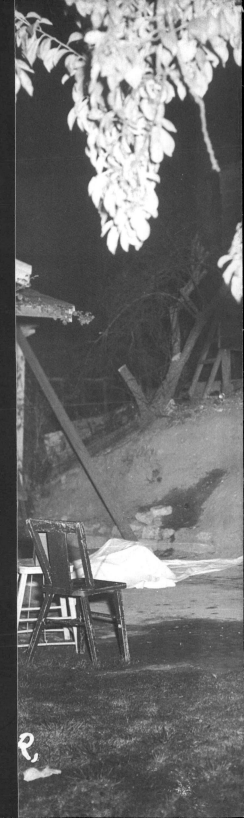

EDITOR: David Cashion
DESIGNER: Jacob Covey
PRODUCTION MANAGER: Anet Sirna-Bruder

———————————————————

Library of Congress Control Number: 2014942741

ISBN: 978-1-4197-1585-3

ABRAMS
THE ART OF BOOKS SINCE 1949

115 West 18th Street
New York, NY 10011
www.abramsbooks.com

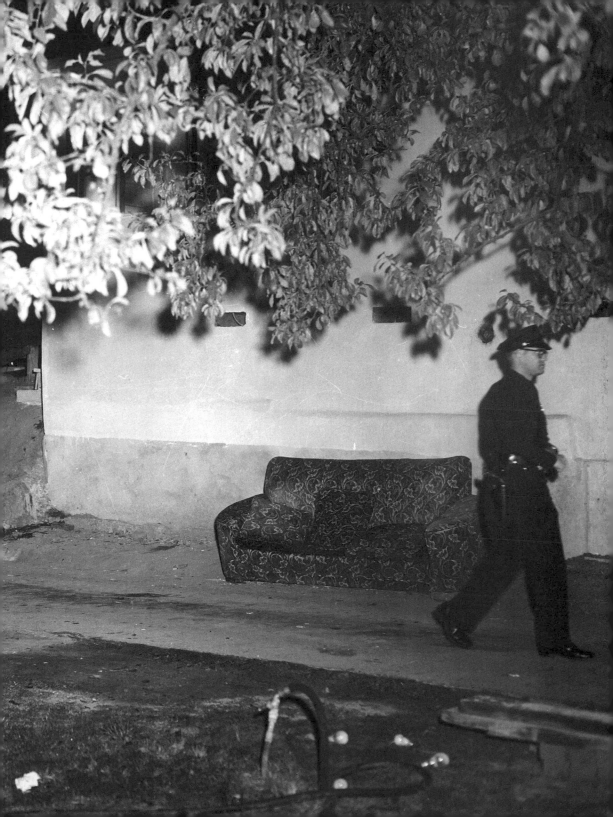

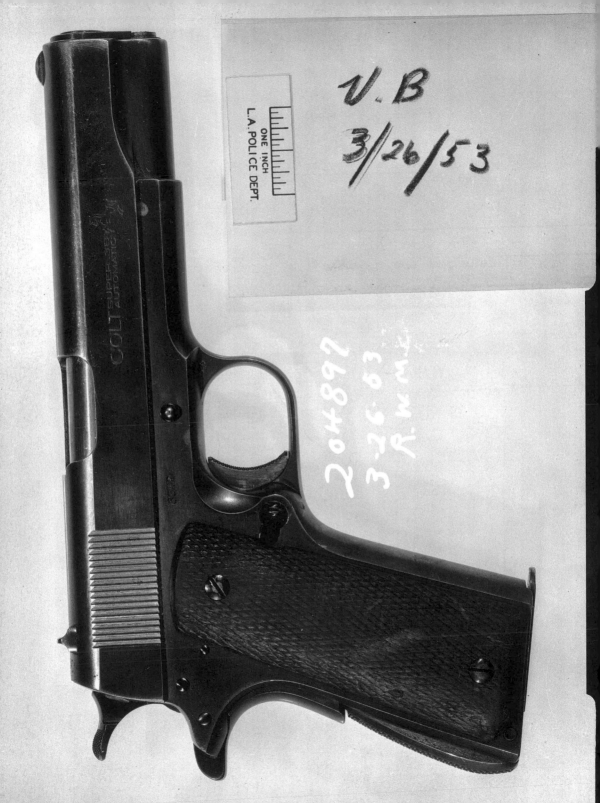

ONE INCH
L.A. POLICE DEPT.

V.B
3/26/53

204892
3-26-63
R.m.

Bank robbery, March 26, Miracle Mile

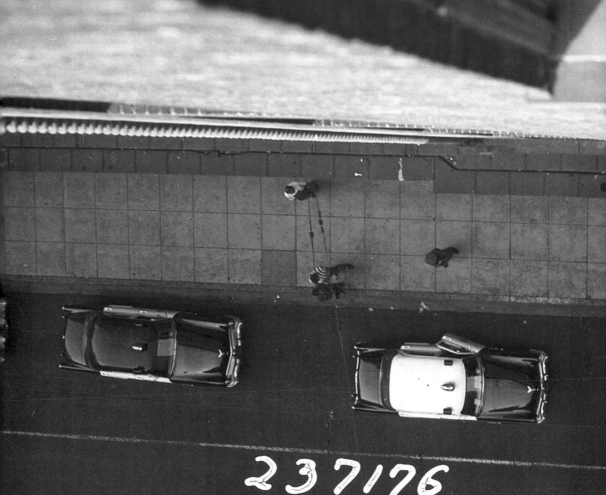

237176
7·3·53 R.F.

Suicide, July 3, Downtown, Biltmore Hotel

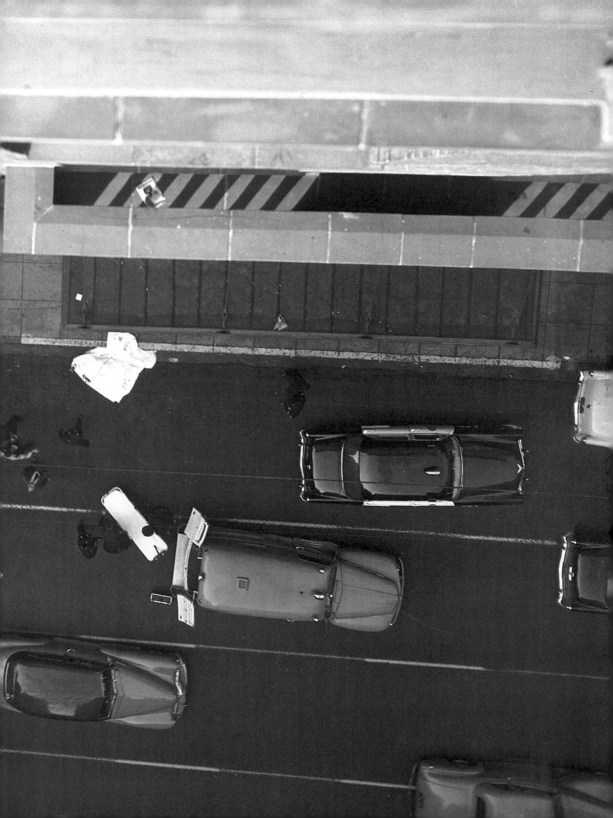

Honey — Don't OPEN

This Box — iT Belongs

To Me — As soon as

You Receive iT- Let

Me KNow

FOREWORD

CHICAGO MIGHT DISAGREE. NEW YORK MOST CERTAINLY WILL. SOME OTHERS MAY WEIGH IN AS WELL. THINK BOSTON, AND PHILLY. STILL MORE MAY TAKE ISSUE.

Each of those destinations has a fine police department. Many of them claim unique histories. Some of which are lengthy and impressive. All have common ground.

None is the LAPD, and none has such a storied past.

Accordingly, none has amassed a history that supports a book of this magnitude. This volume isn't just about crime scene photos. All PDs have them. The narrative offered on these pages, and its author, are equal parts of the book's relevance.

Therein lies the distinction.

The Los Angeles Police Department is, and has been, a great police force for many years. Interest in the work done by the LAPD's men and women is easily quantifiable. Look at television, look at motion pictures. Then, predate both media to radio. The LAPD was there, and not by chance. Simply because the public consumed broadcasts of LAPD antics and activities via *Calling All Cars*. There was *Then* and is *Now* a market for virtually all things LAPD, including its history. In that market is a demand, hence programming and feature films, and of course, books.

Bank robbery, March 26, Miracle Mile

It's been 10 years since James Ellroy collaborated with then Chief of Police William Bratton to bring crime scene photos out of the LAPD archive and into the publishing world. There were many descriptions for the book and the photos. *Fascinating, chilling, artful* were but a few. The photos were great. The narrative, however, not so much. One of the book's drawbacks was the lack of text. Discovering the circumstances depicted required a journey away from the image, no matter how striking it was. Akin to an eighth-grade math book, the answers were in the back.

LAPD '53 is a look back at a different Los Angeles, and a different LAPD. Sure some of the scenes will appear familiar, as the nature of crime has a level of consistency that is immune to the passage of time. The photos, however, won't require page-flipping. The stories for many were found through various means during the research phase of the book. Thus, the photos are supported by Ellroy's narrative. But it's not just Ellroy's prose that sets this work apart. The brew also includes his vast knowledge of LAPD history, the likes of which remains the envy of those associated with this project and the Los Angeles Police Museum, the organization that benefits from its long-standing association with Ellroy.

Most certainly Ellroy is a supporter of the men and women of the LAPD. He credits them with saving his life many decades ago, at a time when his credentials were not so numerous. Since that time, Ellroy has had 19 books published and has earned praise throughout the literary and literal worlds. He's also seen a half-dozen of his movies made. Now he has spent more than 30 years as one of this nation's most respected novelists. He's a true master of the written and spoken word. For the past decade, he has devoted himself to supporting the folks who collect and preserve LAPD history at its museum in the Highland Park neighborhood of Los Angeles. It's a place where there is no disagreement about police history.

So it's time to get over it in Beantown, the Big Apple, the Windy City and the City of Brotherly Love.

LAPD rules!

These are words often heard beyond these pages and frequently spoken by the Scots/Angeleno author of this book. Words true today and true more than six decades ago. Yes, the cops in L.A. ruled in 1953. They reported to one of the most revered cops of the 20th century—William H. Parker. He was tapped to reform a police department gone astray, and he succeeded. His tenure as LAPD Chief spanned 16 years. So undeniable were his achievements that the LAPD's world-famous headquarters took Parker's name not long after his untimely death in office during the summer of '66.

But Parker lent his name to more than a building. It was a philosophy of policing, one that served L.A. and many other places well for many, many years. A rather stern attorney and decorated D-Day vet, Parker was tasked not just with the reform of the LAPD, but with the construction and completion of an institution.

Reform most certainly was a major goal. Parker delivered much more. He expanded the influence of the LAPD beyond the City of Angels. Families brought the LAPD into their living rooms, spurring curiosity and, ultimately, admiration.

To say his was a flawless administration would be a misrepresentation of history. Parker once acknowledged that as long as the LAPD recruited from the human race there would be problems, and there were. Almost immediately for the Catholic chief and maverick.

A look at one of Ellroy's previous works, *L.A. Confidential*, reveals a fictional treatment of one of Parker's early challenges. Often referred to as Bloody Christmas, it would better be described as a mass jailhouse beating. Eight cops were indicted for lumping up some prisoners who were rumored to have gravely injured an LAPD officer. A bunch of them went to jail. One of them was a Police Academy classmate of Parker's driver, Daryl F. Gates. Post-LAPD, the disgraced cop found his true calling, as a barber.

Parker had just concluded the mop-up of this scandal when 1953 rolled around. That's important to know because the LAPD of 1953 was *his*.

Parker *commanded* the LAPD.

He had to in order to reform the LAPD.

He had to in order to build the institution that the LAPD ultimately became.

He had to in order to gain the confidence of Hollywood.

Remember, *Dragnet* turned out to be little more than an audition for the LAPD. If there were an Academy Award for lifetime achievement by a police department, the LAPD would stand alone at the podium. Parker should be around to accept the award. Ellroy should make the presentation. Both would thank those who serve and have served.

It's a pretty cool visual, the tall, incredibly eloquent author sharing the stage with the authoritarian chief wearing an Eisenhower jacket and horn rimmed glasses. What would they be conversing about?

LAPD '53!

Shooting, November 11, Hollywood

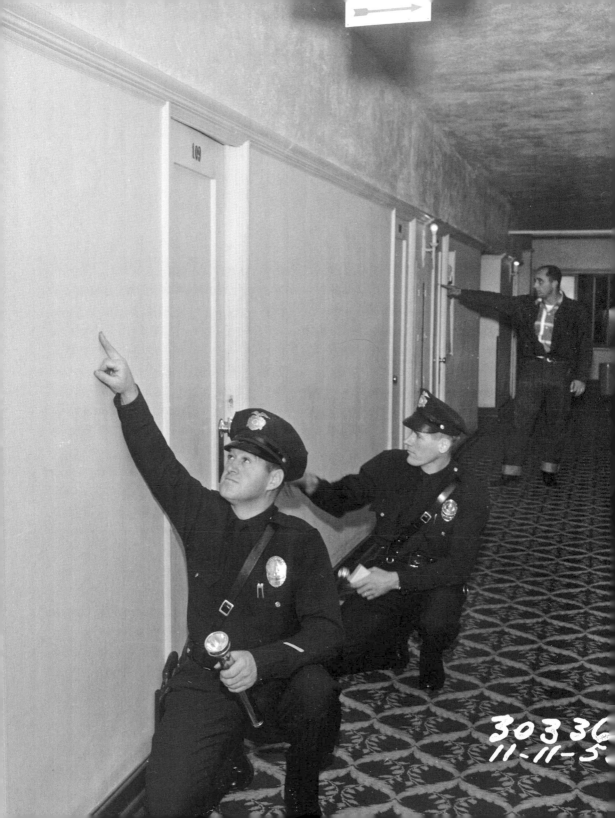

30336
11-11-5

More contemporary and real is the conversation about the conception and creation of this book. Since the beginning of the Museum's association with James Ellroy, he has aspired to introduce LAPD history into any dialogue about Los Angeles. As many do, he firmly believes that the history of this city is the history of the LAPD. In good times and bad, the evolution and development of the nation's second-largest city has mirrored the evolution of its police department. One of the principal methods of entering into this dialogue is via the written word, specifically as found in books. This approach offers an ancillary benefit for the Museum—a publishing program.

Museums that publish books are typically much larger, more established, and not as topical as the Los Angeles Police Museum. A great level of prestige is assigned to those institutions that publish regularly. Frankly, it is unheard of for a museum of this size and scope to engage in a publishing program with an author as accomplished as James Ellroy. Plain and simple, it's an honor, particularly since it was his idea, and one that he stands behind wholly.

The Museum gladly accepted his proposal and began work by culling crime scene photos from the various decades of the last century, beginning with the 1920s, as the initial concept was to provide a sampling of photos from across the span of four or five decades. It was during this process that Museum staff and volunteers recognized that a single year provided more than enough photographic material to illustrate this book. As research into the photos progressed, project personnel further realized that 1953 was a year of particularly unusual cases. Immediately recognizable were the photos from the murder of Ruth Fredericks, who was killed by her husband, whose 1953 handle was the "Croquet Mallet Slayer." More photos, those depicting a dark day when an LAPD officer committed a double-murder suicide, were also immediately recognized. As the number of unusual cases grew, so did the variety of crimes depicted. The project quickly satisfied Ellroy's

criterion that the book not be a collection of "splatter shots."

Upon compiling the stories and photos from 1953, all were confident that the material comprised a book worthy of publishing. As was the prestigious New York publisher Abrams Books. Work commenced at the Museum immediately after a publishing agreement was reached. Photos were scanned, more research was conducted and completed and finally the text was written.

Unlike many books that have a single author responsible for its creation, this was a collaborative effort. A group of volunteers, each very interested in L.A. and LAPD history, devoted many, many hours to the various aspects of the book. Two are accomplished historians in their own right. More project personnel were drawn from Museum staff. The final composition of the project team was a perfect mix of very accomplished supporters of the LAPD and its Museum, directed by a very patient yet driven bestselling author. The book demanded nothing less, and no

one involved was willing to provide anything less.

While working to produce *LAPD* '53, those not entirely familiar with the LAPD of the era sought to learn more about the year, the city and its police force. The Museum's unique collections helped with this learning curve. So did one of the Museum's long-serving volunteers, Cal Drake. Cal graduated from the LAPD Academy in December 1952. Largely, his rookie year was the subject matter that all were consumed with.

Beyond the living history offered by the now-retired Sergeant Drake, the Museum's paper and photo collections helped re-create the technology-bare year under consideration. From the Museum's collection of LAPD annual reports was drawn the 1953 edition. The full year's run of daily bulletins was examined over and over again. Each 1953 issue of the *Beat* magazine was scrutinized, as were photographs held in the Museum's archive. County morgue records were viewed in a space nearly as unwelcoming as its examination room. Chief Parker's

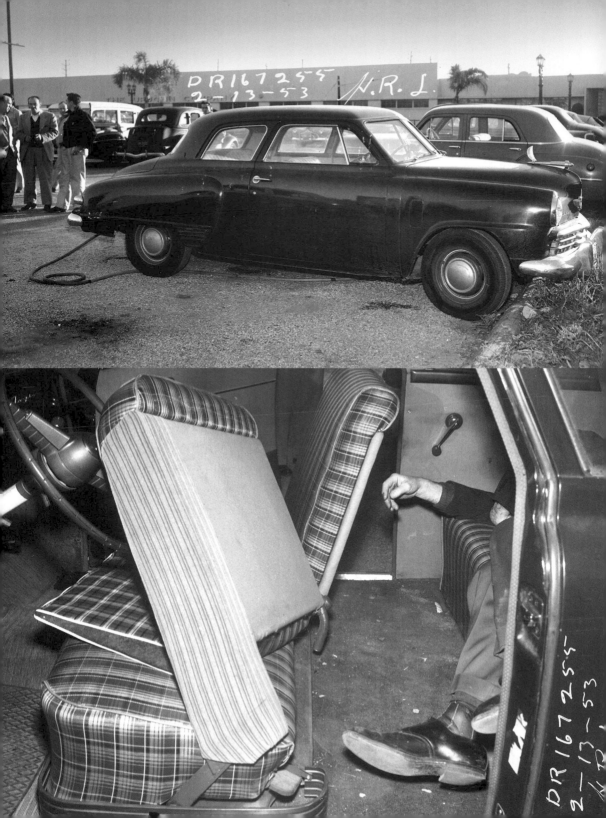

scrapbook of news stories, along with that of Policeman James E. Barrick, housed information not easily retrievable but extremely valuable to the project.

Cumulatively, the resources amassed at the museum assisted greatly with understanding 1953's big picture and some of its finer details, too. The book crew culled, considered, and concluded via research methods that were never fit for the quiet confines of any library or laboratory. Always lively, sometimes raucous, the work was completed effectively and enjoyably. These were the right people at the right time to ensure this blend of images and language made it to bookstore shelves.

During the process, news reports were discovered in the chief's '53 clipping book that spoke of his possible replacement. It seemed unlikely, as his reforms were still in their infancy. The LAPD's new home and the building that would later bear his name was under construction. Organized crime hadn't packed its final valise. Air operations hadn't yet begun. The

LAPD wasn't desegregated. Motor cops didn't have helmets yet. Sergeant Friday hadn't taken on Bill Gannon as a partner yet.

Sure, these major undertakings could be passed along to a succeeding chief, but why would a city want to derail such major undertakings? Well, they didn't. Parker continued with the reformatory evolution he had initiated just a couple of years previous. The aforementioned would occur on Parker's watch.

The photographic images being dealt with also revealed an evolving uniform. Parker's own portraits show changes in his uniform hat. He abandoned the suicide strap that simultaneously helped support the equipment belt and provided a handle for crooks who wanted to risk an unauthorized polka with a uniformed cop. The book crew noticed that uniform hats were of the eight-point variety and always worn. There were no short-sleeved uniform shirts, walkie-talkies or name tags. Uniform insignia and accoutrements were simple but classy. Signs of efficiency were found

everywhere. All things considered, Parker's was a small force, having just enough to get the job done.

Thin ranks weren't unique to Parker's era. The 1895 annual report from the Chief to the Police Commission contains a request for more officers. The LAPD has been understaffed for a dozen decades, yet it manages to endure and indeed, on some occasions, thrive.

Such was the case with my times in and around the LAPD. They now number more than 30 years, beginning with my senior year at USC, when I interned with the Planning and Research Division. I transitioned directly from interning to the Police Academy and enjoyed 20 years of service that took me to a variety of plainclothes and uniform assignments. I worked patrol in all four bureaus (regions) of the city, concluding my time in the Northeast area. During this tour, the Los Angeles Police Historical Society was preparing to take possession of the oldest police station in L.A., the Highland Park Station, for the purposes of opening an LAPD history museum. This building was the predecessor to the one in which I was last assigned and a logical place to exhibit the LAPD's past.

In 2001, the Historical Society opened the Museum, making it one of the only full-time municipal police museums in the country. A couple of years later, and not long after my LAPD retirement, I took over the Museum as its executive director, leading a small staff, working with a large board of directors and assembling a dedicated and truly talented corps of volunteers.

The ensuing years, 10 of them as this is composed, brought great change to the Museum, its collections and its reputation. Nothing is as it was when I arrived. The Museum is populated with professionally built exhibitions. The audio tour is the only one of its kind in the nation. Major building and preservation projects have been completed, and the Museum has emerged as a leader in this segment of the larger museum community. The Museum has received

news coverage throughout the world and has been featured on television shows on many occasions. Visitation has increased greatly, and people who generally would not experience the Highland Park area of L.A. make it here just to see the Museum.

It is these people who tell us how wonderful the Museum has become. For as flattering as these words are, the Museum is but the public countenance of so much more. Conserving and preserving the LAPD's history is not as visible to the general public. These efforts go on behind the scenes, where we preserved the only known portraits of some of the LAPD officers killed in the line of duty. We secure and care for bejeweled, gold badges.

The oldest known photos of LAPD officers remain in residence here. So does a collection of all books about the LAPD, which was assembled by a retired police officer. And all of it is done for one reason . . . to support the men and women of the Los Angeles Police Department, an agency that was born in a time before technology permitted constant public comment.

People behaved better *Then.*

They dressed better *Then.*

Those that didn't might *Now* be found right here.

In *LAPD '53.*

Glynn Martin
LAPD, RETIRED

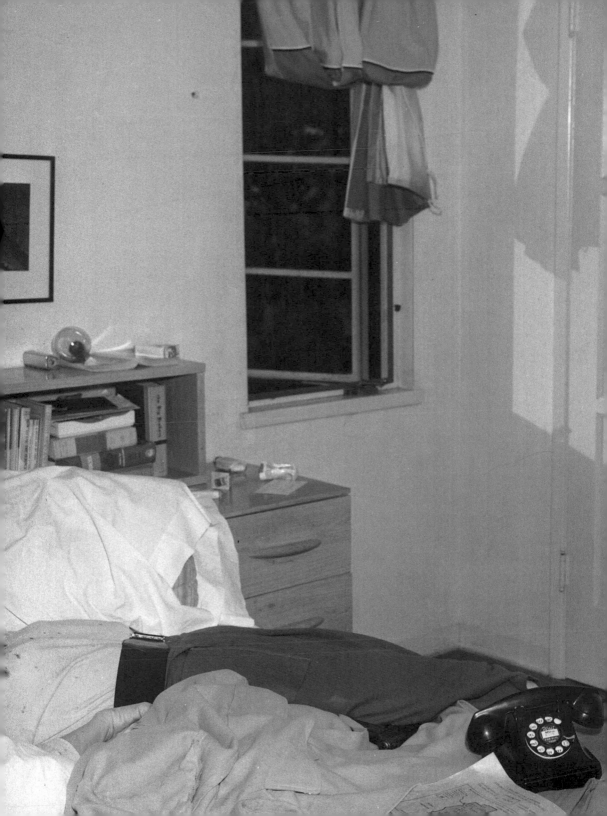

Suicide, March 15, Echo Park

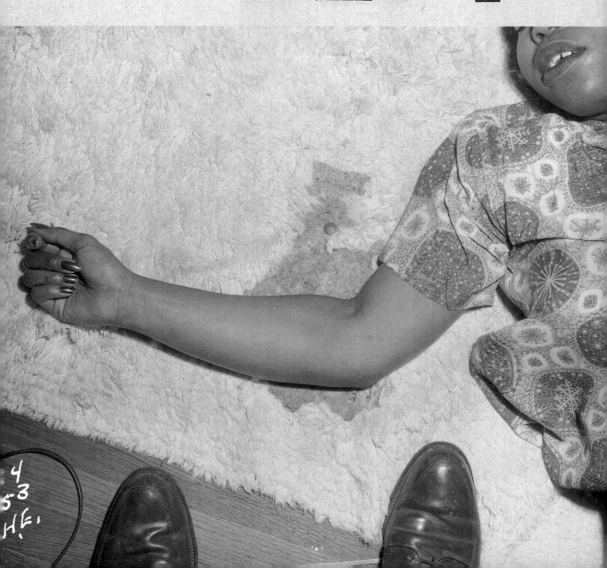

THE *Los Angeles Police* DEPT

1953

4
53
H.E.

JAMES ELLROY

INTRODUCTION

THEN TO *NOW*—ONLY 61 YEARS. *THEN* TO *NOW*— THE QUINTESSENTIAL AMERICAN BOOMTOWN TO THE QUEEN CITY OF A NEW MILLENNIUM.

Then to *Now*—an ever-growing topography that renders street scenes from *Then* nearly unidentifiable *Now*. Sixty-one years of history, from the moment the first flashbulb popped to the moment that I write these words. My city—unrecognizable *Now*, longed for as it was *Then*. And the police agency that has provided these photographs—immutable in its resistance to change, a motor of change, a chronicler of change depicted in jailhouse mugshots and crime scene pix.

It is commonly held that cities get the police department that they deserve. Los Angeles proves the case true. L.A. has always been about expansion. The Los Angeles Police Department has always been about imposing constraints on an unruly town infused with a sense of its limitless potential. Thus, America's most provocative city *earned* America's most provocative police agency. L.A. is the most overscrutinized and over-analyzed city in the United States, and the LAPD keeps pace as the most overscrutinized and overanalyzed police department. Both stand as urban cultural phenomena—and both tell us this:

Urban planning is futile. Great cities have unstoppable wills of their own. Their greatness, their boldness, their *beauty* magnetizes a disproportionate array of fiends bent on plunder. Crime, et al., cannot be eradicated. Crime *can* be interdicted and occasionally subsumed—but only on an ad hoc basis.

Homicide, April 9, Jefferson Park

Hence the photographs in this book.

They portray trouble in paradise.

Great cities resist containment. Urban planning is futile. Crime, et al., cannot be eradicated. Plunder must run its course. Now, the flashbulbs *pop*! It marks the aftermath of plunder. It limns interdiction in a pinpoint marking of *Then* as *Now*.

The interceding years between 1953 and *Now* encompass the canonization of photography and its perceived ascent as an art form. Photography denotes the march of time through the modern era. Cities have built upward and outward. Photography is the moment-to-moment depiction of flux. America '53—unrecognizable when compared to the America of the 21st century. 1953 Los Angeles was underpopulated as *Then* and overpopulated as *Now*. The growth potential of *Then* was wildly misrepresented when viewed from the standpoint of *Now*. The arty police photography that has become a cliché *Now* was *Then* the idée fixe of the frou-frou cognoscenti. The police photographs in this volume achieve artfulness only because LAPD camera jockeys aimed their cameras with pure cop efficacy.

We've seen too many splatter shots with artful disarray. We've seen too many dead junkies with spikes in their arms, overjolted off Big "H." Dig that gap-tooth wino who checked out in the gutter on East 5th Street. See that marquee for the burlesque show in the upper right corner? *This* pic is instantly gratuitous and redundant.

The photographs in *this* volume seek to rebut crime scene chic. The photographs in *this* volume stand unified by their reliance on plain and simple perspective.

Check *this* collage. It portrays rasty Bunker Hill, just west of downtown L.A.

Bunker Hill is gone *Now*. Bunker Hill shabbily thrived in 1953. It was slated for ultimate bulldozing *Then*—because L.A. *had* to build up and out. There were terraced hillsides full of flophouses. They were inhabited by rumdums, hopheads, slatterns, pachucos, fruit hustlers, cough syrup guzzlers and hermaphrodite he-shes.

Dead body, January 7, Bunker Hill

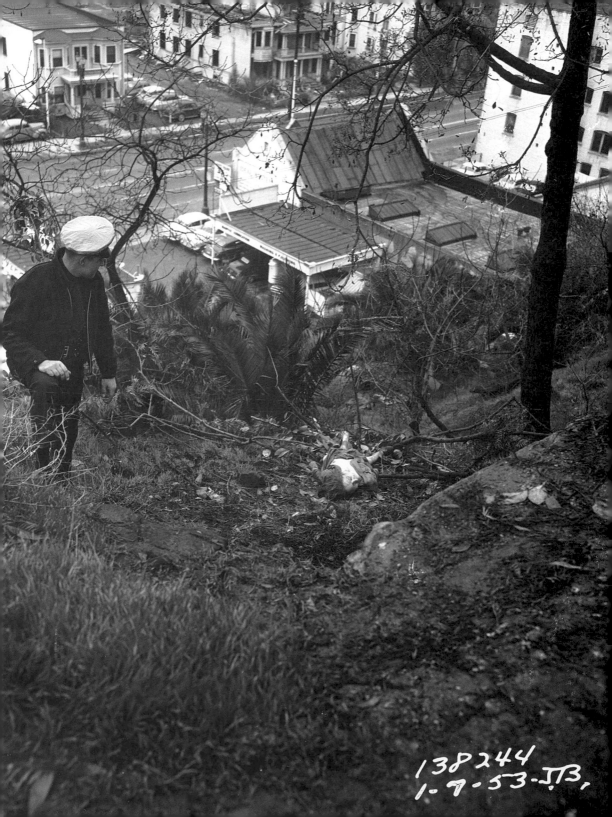

138244
1-9-53-JB

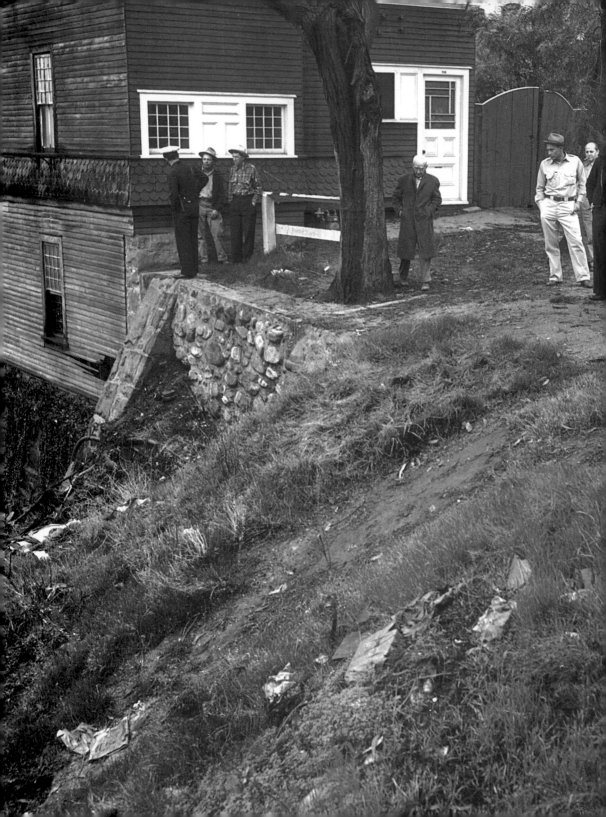

138 244
1-7-53
JJ3.

The cribs had to go. The denizens, ditto. Urban expansion beckoned. Development gelt speaks big. Check that dead ginch sprawled in the weeds on West 4th Street. It looks like a sex-snuff snapped by Weegee. It's January '53. Feel the cold air. The dead frail is Jane Doe #2 of that year.

It's not a Weegee pic. And it's not a sex job. The woman was flying high on a snootful of jungle juice. She took a spill and went down dead on a Bunker Hill hillside. And L.A. looked *goooooood* that year.

Note the old houses, old hump-backed cars, a few cars with that then new-fangled rocket-ship look. They stand now as historical markers.

The overall context bespeaks professionalism. There's policemen and stretcher bearers. They seem to defer to the woman. Cars whiz westbound and ignore them. The Victorian houses look passing-of-an-era threadbare. L.A. is moving up and out. The once-grand pads sheltered single families a coon's age ago. Now, they're the crazily cramped crawlspaces of wetback dishwashers and jangle-nerved junkies.

Dead body, January 7, Bunker Hill

The LAPD's Central Station is a few blocks northeast. Let's extrapolate here. Two bruisers working the Central Station DB are leaning on a window-peeping 459 man. Both of the cops are dick-deep in a shit day. They're thumping the 459 man with a phone book.

You will not see that photograph in this volume. More's the pity.

The dead woman took a spill. She was blotto. Reach for your own subtext here. This photograph encourages you to do so. *Why?* Because it is void of artifice.

Indulge your own narrative. The woman just got the word that her lover, husband or teenaged son got snuffed in Korea. Maybe she was double-looped on drugstore dope along with the hooch. Maybe she just left a loin-lurching assignation with Ten-Inch Tomas, the tumescent tailback on the Belmont High football team. The 30-year age gap? Entirely predictable. Why? Because this is a police photograph.

Great police photographs offer up explicitness in perfect proportion. Great police photographs grant the viewer narrative wiggle room and urge them to provide their own subtext.

Consider *this* photo.

It's quintessential L.A. *Then*. It emits undertones of L.A. *Now*. The pic reeks of creepsville Laurel Canyon. The canyon straddles West Hollywood and Mulholland Drive. It's pricey real estate—but the pads look cheapshit. Laurel Canyon is a perv zone and death zone. Silent film heartthrob Ramon Novarro was offed in his canyon crib in '68. He picked up two rent boys and brought them home. They asphyxiated him with a giant dildo. Cut to '81 and the "Four on the Floor" murders. John Holmes—"Mr. 14 inches"—is dick-thick in it. The snuffs derived from cocaine intrigue and a botched home invasion. The means of death was lead pipe blows to the head. Laurel Canyon is Shit City. It's a lurid lodestone for rock-and-roll scum and sicko Sids of all stripes. Cut back to '53. Our more recent *Thens* are violently perverse. Our photo-subject *Then* is hauntingly pathetic.

Ghastly self-annihilation. Sexual identity horrifically asserted in death. The suicide tableau for All-Fucking-Time.

It's artful.

It's ingenious.

It bespeaks an unutterable horror. The man could not take it one second longer. The man spent a full week composing his own death.

He purchased a woman's swimsuit, bathing cap and fetishistic white boots. He fashioned a system of pulleys, weights and chains in the living room of his house. The living room is spacious, in the California-Spanish style. The man knew he would be studied, scrutinized and photographed in death. He intended to make a statement. It might have been "I'm a woman in a man's body" or something never brought to formal consciousness. It came down to "look at me" in the end.

Look:

The man deliberately prolonged the death process. An elaborate system of candles, cords and weights caused him to self-exsanguinate. Now, cops and a forensic crew are *looking at him*. A tech man is measuring a cord stretched taut, from the body to a point near the living room couch. Patrol cops and detectives are viewing the stiff.

His arms are cinched in front. His feet are trussed together. He's a large man with hairy legs in a tight woman's swimsuit. His head lolls on his chest. Read the cops' faces. It's "*Holy Shit*" crossed with pity and contempt. One cop is studying the dead man very closely.

The cop's name is Donald Grant. He's wearing a new-looking suit with an up-to-the-minute cut. Grant is about 45. Grant looks intelligent and *mean.* He strongly vibes film noir. He could be the psycho cop with the rubber hose and the personal call to vendetta. He's fresh off a tavern heist blastout. He worked the Caryl Chessman "Red Light Bandit" caper in '48. Chessman accused Grant of beating the shit out of him at Hollywood Station. That was an earlier *Then.* Laurel Canyon '53 is this foto *Now.* Maybe Grant *did* tune up Chessman. Maybe Chessman was playing the pity card

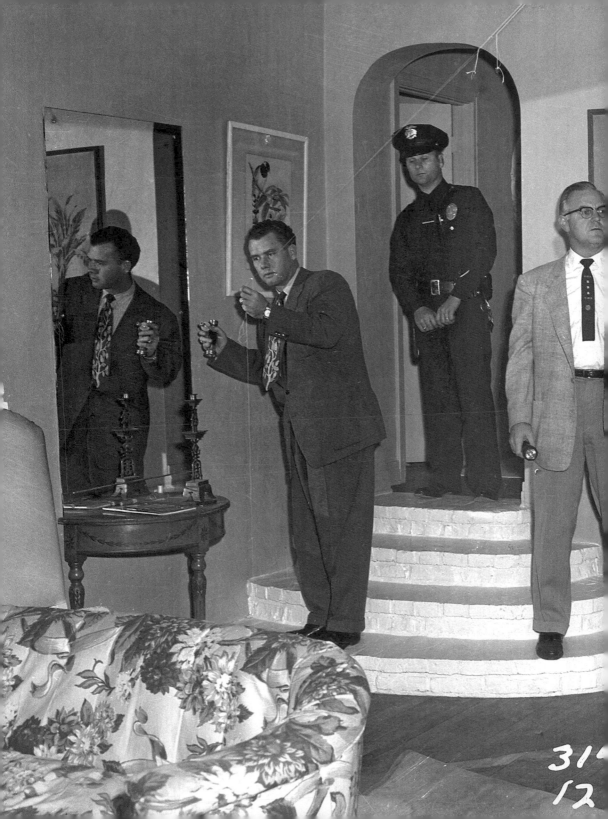

31
12

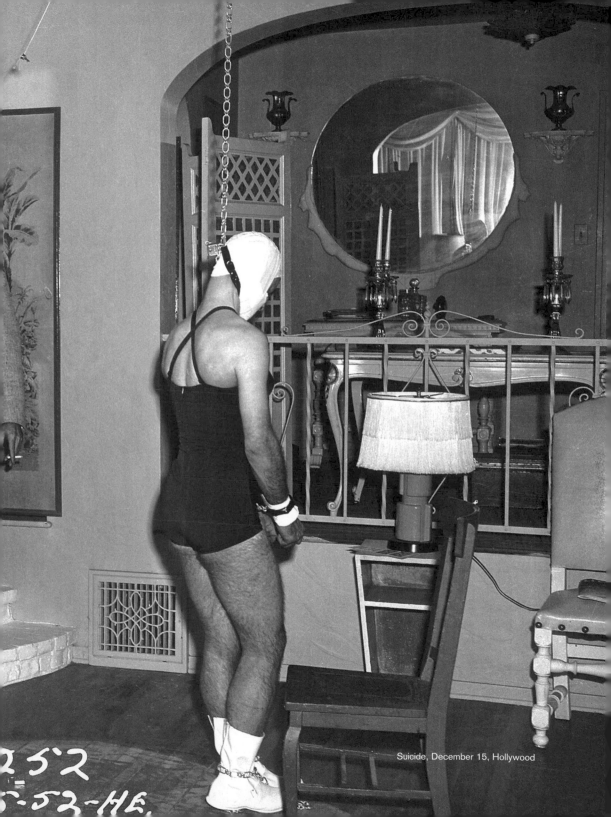

Suicide, December 15, Hollywood

with the press. Look at Grant's eyes *Now*. They're laser beams. He's looking through the dead man.

Maybe Grant possessed the gift of prophetic imagination. Let's cut from '53 to a more-recent *Then*. It's 5/2/60. Caryl Chessman enters the green room at San Quentin. He sits down in the hot seat and waits for the eggs to drop. *Aaaaaaaah*, the wages of sin are death! Is Grant looking through the dead man and *at* Caryl Chessman? Is it because the dead man is beyond his comprehension? Is it because Chessman is a tried-and-true, empirically confirmed freak?

This photograph says, "I don't know."

The suicide got minor ink as the "weirdest in Hollywood history." What did the dead man think he was doing?

211 P.C.

Savor that penal code designation.

It denotes armed robbery. "The theft of money or property through the threat or use of violent force." It's the king of street crimes. Its perpetrators are the kings of all penal institutions. Armed robbers be *baaaaaaaad*. They'll go in hard to get the goods or the gelt. They've got the gat. They threaten innocent people with loss of life. They risk death by gun-happy clerks or roving cops responding to silent-alarm calls. Armed robbery is a wild holdover. Stagecoach heists were risky propositions. The modern-day equivalent is the liquor store caper.

Liquor stores connote *lowlife*. Their stock-in-trade is the shit that lays you low. Booze and cigarettes. Lash your liver, scorch your lungs. Slim Jims, pork cracklings. Rotgut whiskey and short dogs of T-Bird and muscatel. Unfiltered Camels and Kool Filter Kings. The wages of sin are death! Liquor stores are state-licensed death zones. Forget every heist flick you've ever seen. *The Killing*, *The Asphalt Jungle*, *Plunder Road* and *Odds Against Tomorrow* are all motherfucking jive. Think two skinny hopheads, hellaciously hot to feed their arms. They've got the heebie-jeebies and the shimmy-shimmy shakes. They're passive putzes who want to nod out on Cloud 89—but now they *need a fix*!!!!!! Thus, they morph to daring desperadoes.

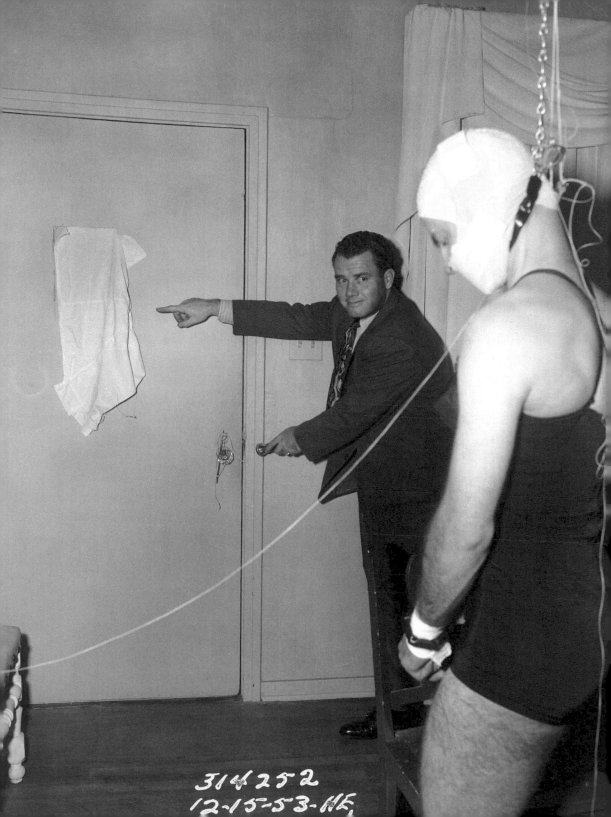

314252
12-15-53-HE

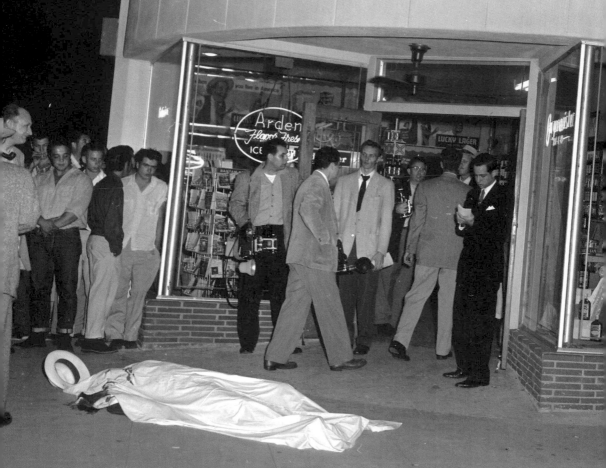

211 P.C.

Savor that penal code designation.

Forget jewel heists. Forget race-track robberies. Forget armored-car capers. The zenith of 211 is the liquor store job, as performed within the inner city.

LAPD Robbery detectives be de biggest and *baaaaaadest* o' de bad. Dat's because dey go after de men with de guns and de penchant to cause pain and death. The law of the jungle carries a binding 211 P.C. clause.

It reads like this:

If you perpetrate armed robbery, we will kill you. Junkie heister with the shakes, beware! Liquor store proprietors stash pistols and shotguns below the counter, and are inclined to use them. LAPD Robbery dicks may be poised behind false-front refrigerators, armed with Ithaca pumps.

211 P.C.

The wages of sin are death!

Let's assume the perspective of a neophyte heist man, circa '53. He's never pulled a 211, but he's considering it now. He's unhip to the 211 gestalt and figures he's only going to

Attempted robbery/justifiable homicide,
August 7, Crenshaw

do it once in his lifetime—which puts the odds in his favor. He is unhip to the trigger-happy proprietor and bad-ass Robbery cop archetypes.

Let's say he's a Marine, up from Camp Pendleton. He's temporarily shacked with a boss babe off of 40th and Western. They need gelt, coin, moolah, scratch, dinero. He knows that there's a liquor store off of Santa Barbara and Crenshaw.

Santa Barbara Avenue would be renamed Martin Luther King Boulevard. The great civil rights leader dreamed dreams of racial equality. Our dipshit dreamed dreams of bitchin' boudoirs with his boss babe and a dip down to TJ to catch the donkey show with his jarhead pals. He's a nihilistic nabob who just pervertedly punched a one-way ticket to hell.

And, dig this:

He *dressed* for his foray into armed robbery. He's neatly attired—and he's wearing white gloves.

He drives to the liquor store. He pulls on a bandana, walks in and up to the counter and demands the gelt.

The proprietor hands it over. Dipshit begins his big getaway. The proprietor pulls his piece and takes a bead on his back.

He nails the cocksucker.

Our boy stumbles out to the sidewalk and falls dead.

Adios, motherfucker.

No bitchin' boudoirs with your boss babe.

No late-night donkey shows down in TJ.

211 P.C.—Armed Robbery.

The wages of sin are death!

Easy come, easy go.

It's 1953 L.A. Life is cheap—*Then* as *Now*.

The lurid.

The lowdown.

The licentious.

The lonely.

As with Miss Swimsuit—the lovesick.

We're inside a lavender love nest on North Sierra Bonita. It's a mile southeast of Laurel Canyon.

It's an accidental pill OD with a garish backstory. Raymond Gross was a 49-year-old "dramatic coach." His life veered south in late March of '53.

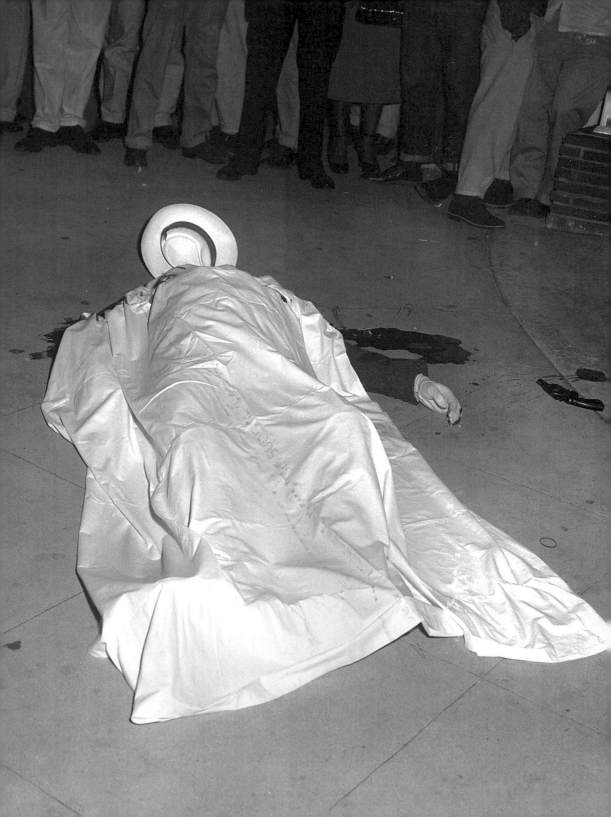

He picked up a hunky sailor named Lee Roy Collins and lured him to his crib. Several drinks and a fracas ensued. Collins beat Gross with an ashtray, a lamp base, his fists and his feet. Gross was found unconscious in his living room and rushed to Hollywood Receiving.

Collins snatched a set of car keys from the pad and attempted to use them on a snazzy ragtop outside. He couldn't kick the sled over and fled the scene on foot. A locker key fell from his pocket as he escaped. LAPD detectives traced the key back to Collins, then billeted on the USS *Duncan*. Gay wags of the era often referred to sailors as "sea food."

Raymond Gross survived a broken nose, fractured jaw and chronic subdural hematoma. Lee Roy Collins went to trial and was acquitted of assault charges. Raymond Gross died of barbiturate poisoning, 7/30/53. He checked out behind phenobarbital prescribed for the now-constant pain from his injuries.

He died while talking on the telephone. He capsized face first into a

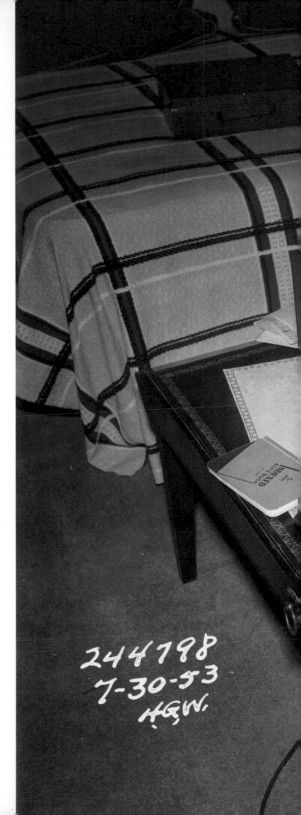

Dead body, July 30, Hollywood

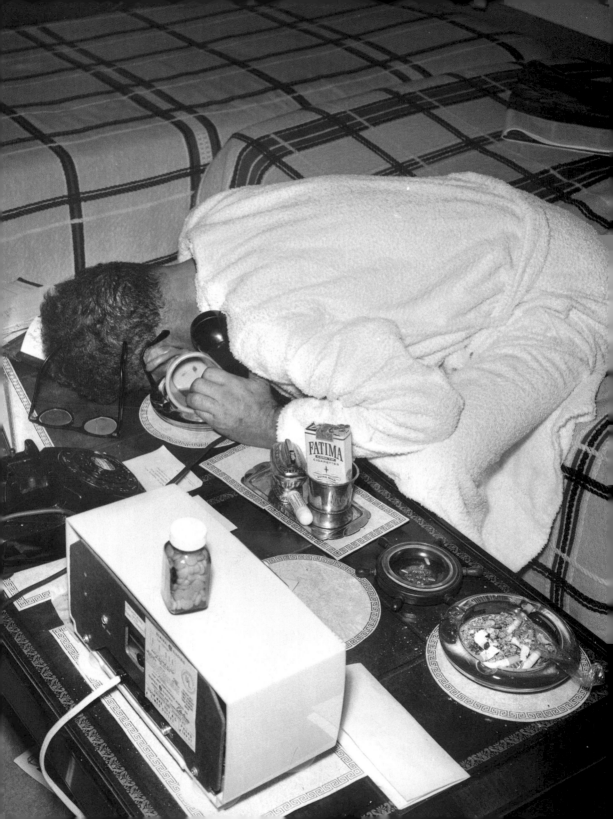

coffee table, still clutching the receiver. An inventory of visible items distills his loneliness.

True Detective magazines.

The vial of phenobarbital.

An ashtray full of cigarette butts.

A framed photograph of a handsome young man.

The young man was not Lee Roy Collins.

Ray Gross, R.I.P.

Who were you talking to on that phone?

The preceding photographs comprise a "mug run." They are not full-face and side-view portraits of felonious individuals—they are examplars of policework themes. These themes are timeless. They form an immutable bridge between *Then* and *Now*.

A sudden misalliance at a southside liquor store.

Depicts the blunt-force trauma of fate.

The swimsuit suicide.

Depicts ghastly inner confusion.

The accidental pill OD.

Depicts love and death intertwined.

The woman on the hillside.

Depicts ruin as an unforeseen stumble and fall.

The preceding photographs are timeless *and* cop-world universal. The details are those specifically L.A. *Then*. Bunker Hill was bulldozed eight years after that woman died. She would not have tripped down that hillside *Now*. The heist man bounty was in force *Then* but has been abrogated by the threat of victims' rights suits *Now*. Homosexuality was roundly stigmatized *Then*. That veil of shame is *Now* lifted.

L.A. looked *gooooooooood* in that more stratified and repressed time. There were fewer people, fewer cars, better views, cleaner streets and better-dressed, more civilized people bopping down them. There's an upside to eras of stratification and repression. It's this: People comported themselves in a more dignified manner, because they believed in God and the rule of law and feared divine and civil censure. This illustrates the key irony of nostalgia. We live *Now*. We wish it were *Then* for all the right and wrong reasons.

L.A. *Now* is the safe-sex billboard at Sunset and Van Ness. A picture of a giant condom frames the words "Why worry?" The sailor who beat Ray Gross half-dead would have done hard time today.

You dig the trade-off, don't you?

There's *no* trade-off in the photographs and text that follow. They explicate events of the time that are both timeless and specific to the era. They express the sentiments of the time in a language of the time that might make inhabitants of *this* time uneasy. The author and archivists who are presenting you this book live in L.A. *Now* and wish it were L.A. *Then*. This book is reactionary nostalgia. This book assails L.A. *Now* and says, "Look how we fucked it all up." This book concedes the point that there's nowhere else for folks like us to go.

L.A.: "Come on vacation, go home on probation."

That's right, fuckers—this book is targeted for L.A. residents, L.A. denizens, L.A. scholars, L.A. boosters, L.A. detractors, L.A. aficionados, L.A. natives, L.A. arrivistes and the Greater L.A. hoi polloi. This book is for the meshugana multitudes who comprise the great L.A. underhung and unwashed. You can't live anywhere else. L.A.'s a life sentence with no work furlough, no parole, no escape clause, *NO EXIT*. You can't get out—and you don't want to. You make do with the overcrowding, the pollution, the pervasive grime, the swarm of dubious people and the billboard at Sunset and Van Ness. You need a dose of the good old days, suffused with L.A.'s trademark mix of glamour and slime. You need that noxious nachtmusik of 1953. You've had it with repugnant rap and the hoo-ha of hip-hop. You want Lawrence Welk—blasphemously blended with *baaaaaaad* bebop. Here it is—magnificently, motherfuckingly yours.

LAPD '53.

Your host,
James Ellroy

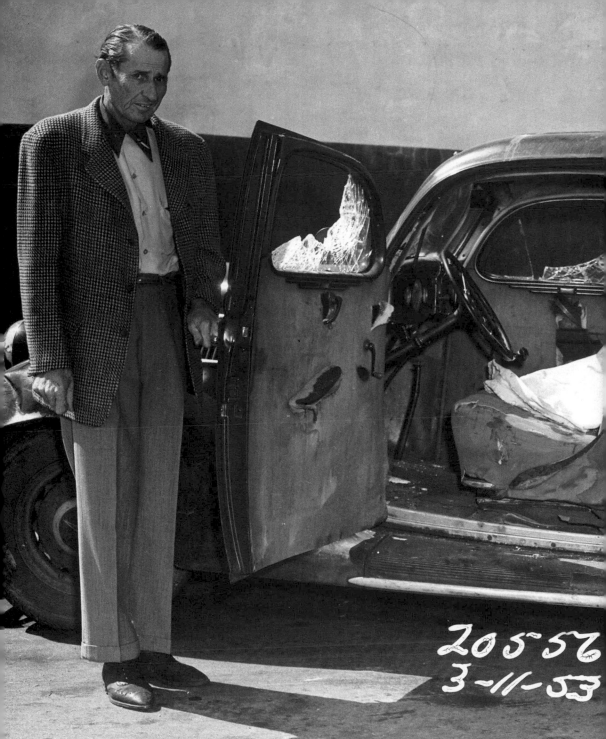

20557
3-11-53

Assault with a deadly weapon, March 11, Harbor

LAPD '53

HAPPY NEW YEAR'S, KATS. IT'S '53 NOW. EISENHOWER/NIXON TROUNCED STEVENSON/SPARKMAN AT THE POLLS THE PRECEDING NOVEMBER. L.A.'S A BOOMTOWN.

The Korean War is still going—but Ike has pledged to put the quietus to it. The Rosenbergs are scheduled for a hot date with the hot seat at Sing Sing. *Confidential* magazine deliriously delivers the dish. Who's a homo, who's a lezbo, who's a dipso, who's a hophead, who's doing who. We're moving into the apoplectic epoch of sizzling *sin*uendo. L.A.'s the epic epicenter of all this shimmering shit. L.A.'s cosmetically copacetic—but lists on a lurid low tide. The LAPD surgingly surfs that tide. The cops are isolated men in an isolating profession, deprived of conventional illusions and traumatized by their daily contact with scum. I'm their kiddie konsort. I'm not quite five years old— but possess superhuman powers. I'm a snot-nosed toddler on the one hand. It's my cover. I'm a big little kid with a shock of dark hair and beady brown eyes. I live with my mom and dad at 9031 Alden Drive in West Holly*weird*. My mom's a big, good-looking redhead. My dad's a Hollywood bottom feeder with a two-foot schlong. There's a Lutheran church across the carport from our pad. I worship and hide out there. I thrive on parental neglect. I watch *Dragnet* on TV, make myself invisible and hitch rides with LAPD detectives and patrol cops every chance I get. Dig this, fuckers—*I've personally observed every crime scene depicted in this book.* I was there when those flaming flashbulbs popped. *That's* why my coruscating captions carry so much weight.

That's why I can so soaringly summarize the era. I was five years old *Then*. I'm 67 *Now*. My superpowers have metamorphosed into magical memory. *That's* how you know I can deliver the dish with valid verisimilitude.

I'm out on the prowl. I've seen everything that you're about to see in this book. I'm preemptively precocious. I'm crime-crazed. I'm invisible and crawl through the crazy cracks in my all-L.A. world. I know things. I know this above all else:

It's Whiskey Bill Parker's town. We just live in it.

William H. Parker III. The greatest American policeman of the 20th century.

LAPD Chief: '50 to '66.

Reformer. Reactionary. Towntamer. Progressive. Profligate, pious, soused on the sauce.

Bill Parker *was* Los Angeles '53. He was a tub-thumping theocrat. He possessed a pulsing passion for the stern rule of law. He was a brilliantly gifted attorney-at-law. He tempered his deeply held belief in the ordered society with a reluctant—but still pointed—regard for civil liberties. He *knew* the law and understood the limits of aggressive policework. He stamped out monetary corruption in the LAPD and vigorously punished crooked cops. He loathed and feared chaos—in large part because of his alcoholic affliction and chaotic temperament. His authoritarian mind-set was stunningly suited to the implementation of large-scale urban policing. Bill Parker believed in interdicting crime as it occurred and preempting it whenever possible. He deployed proactive methods. Stop potential suspects. Isolate and detain them. Determine their criminal intent or the lack of it. The ordered society comes with a price. That old saw proves itself true: Freedom isn't free.

Parker enraged civil libertarians. His brusque manner drew heat. He defended his methods with ineluctable logic and sterling wit. Cops are cops. They are ad hoc investigators, disruptors and interdictors of crime. They are not sociologists. They do not judge the perpetrators and victims of crime, nor do they or should they

plumb the societal causes that might cause crime to exist. Rigorous enforcement saves lives and reduces the level of depravity and chaos in society—moment to moment, crime to crime, roust to roust. If crime rates are higher in Negro and Mexican enclaves, those indigenous populations will sustain the highest level of interdiction. Said interdiction will provide for a greater degree of safety for the law-abiding majorities of those enclaves. If this creates a sense of persecution, too bad. Crime is a continuing circumstance. Crime is individual moral forfeit on an epidemic scale. The root causes do not apply. Your right to hit your neighbor ends where his nose begins. Your shitty childhood and the established facts of historical racism do not mean shit. William H. Parker championed the ideal of the ordered society for all citizenries. William H. Parker's cops interdicted and suppressed too vigorously on some occasions. Overzealous interdictors and suppressors were rebuked and punished or ducked under the radar of detection. William

H. Parker surely erred on the side of aggressive policework, but hardly in proportion to the degree that his methods succeeded. Bill Parker and the LAPD—"occupying fascist army?" Bullshit—*Then* and *Now*. Crime was—and is—individual moral forfeit on an epidemic scale. It remains a continuing circumstance that must be interdicted and suppressed—*Now* as *Then*. *And*—why mince words or mince at *all*—cops must feel free to judiciously kick ass.

L.A. looked *gooooood* in 1953. Bill Parker's boys provided full-time cop sanitation. Bill Parker was L.A.'s *El Jefe*. I was the five-year-old dipshit kid with wild powers. Why mince words? I was a peeper, a voyeur, a baby fiend gassed on it all. I grooved the ordered society with lunar-looped Lutheran fervor and snout-snagged subversive subscents.

Bebop—blazingly blasting, blasphemously black.

Film noir—fractiously fronting its main theme: *You're fucked.*

Let's talk bop. All the heavies were then gigging on South Central Avenue.

Bill Parker's boys surveilled the surface, but did not join the scene. A pity, that. I would have grokked Whiskey Bill, flying on a snootful of jungle juice. Dig it: He's grooving to mud shark miscegenation at the Club Alabam. Charlie "Yardbird" Parker—no relation—is bleating, blatting, honking and hiccuping "A Night in Tunisia." Reefer smoke hangs humid. The music is decadently discordant. It's the sock-it-to-me sonics of interminable chord changes off a recognizable main theme. It's music for cultured cognoscenti that Bill Parker cannot acknowledge. It takes brains and patience to groove the gist of this shit. It's the musical equivalent of the chaos Bill Parker deplores.

Five-year-old Ellroy is there, watching the Bird take flight. Everybody's chain-smoking unfiltered Camels. The place is one big corroded iron lung. I've got a spike in my arm, I'm orbiting on Big "H," I knew I'd write the text for this book one day, so I've got my voyeur's cap on. My babysitter is an LAPD Narco cop named John O'Grady, aka "The Big O." We drove down to darktown in O'Grady's narc ark. O'Grady's notorious. He's a rogue cop. He's got a hard-on to hurl hurt on hopheads. Jazz musicians gore his goat. They're instigators of insolent insurrection—but he instinctively digs their shit. He's gone too far, already. He popped a drummer named Geordie Hormel and got his dick in the wringer. Hormel was a scion of the Hormel meatpacking clan. He popped William Hopper, later to co-star as Paul Drake on the *Perry Mason* TV show. Bad Bill Hopper was the son of Hollywood columnist Hedda Hopper. *Oops.*

Bebop is insurrectionist music. It's all about oppression, musical taboo and breaking with the slavery of established form. De facto segregation is implicitly portrayed in many of the pix in this book. Note the Negroes in the margins of white crime scene photos. They're bebop balefully eyeballing the upshot of the White Man's bad bidness, while the LAPD takes charge. The southside pix are Jim Crow de-luxe. Colored folk congregate and gesticulate within them. It's '53.

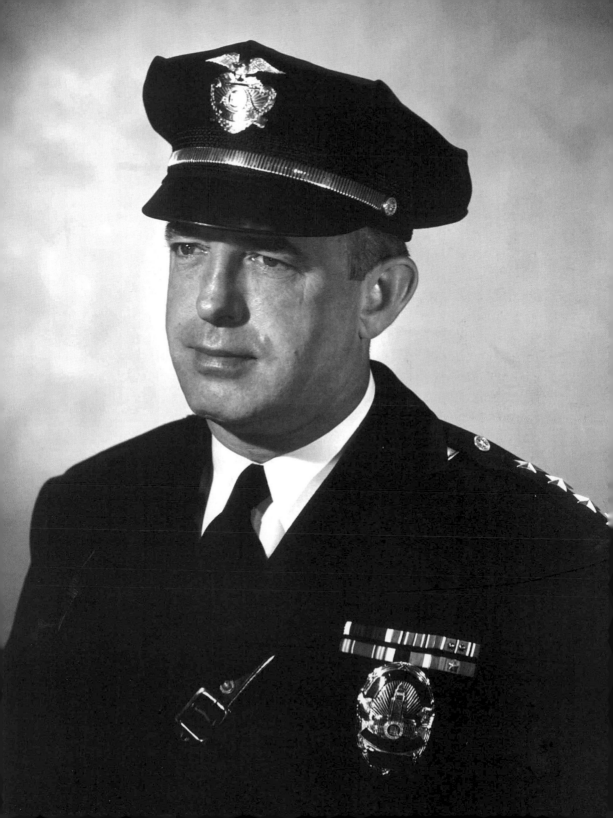

The year is *Then* and a training ground for chants of "Freedom Now!" Those chants will take hold a decade hence. Bill Parker could not, would not, and *did* not heed them—because they came backed by civil disorder, and he would not acknowledge the solvency of any grievance that caused chaos and served to disrupt the ordered society that he wished so dearly and served so assiduously to preserve. He sought to quash chaos in the '65 Watts riot and was right to do so. William H. Parker was a visionary law-enforcement officer. William H. Parker was a hidebound drunk. Saul Bellow wrote, "Everybody knows there is no fineness or accuracy of suppression; if you hold down one thing, you hold down the adjoining." Parker did not know that, or chose not to integrate it into his professional thinking. Parker's inflexible police methods did not cause the '65 riot, nor was the '92 riot caused by the actions of his police chief successors or LAPD cops on the street. Violent reaction to any perceived injustice is never permissible within a free society.

Crime is a continuing circumstance. Crime is individual moral forfeit on an epidemic scale.

You dig the trade-off, don't you?

We needed Whiskey Bill Parker's methods in 1953. We need a reinstatement of them today. Parker's beloved *Pueblo Grande* built up and out during the time of his stewardship. He could not contain its growth nor curtail its change of complexion. He wanted to keep it the way it was *Then.* I cannot fault him for that. It's why I'm writing the text for this book. *Then* to *Now.* All notions of the civil contract and the ordered society have been trashed. Where's Whiskey Bill Parker when we really need him?

Now to *Then.* We're back at the Club Alabam. Five-year-old Ellroy's geezing Big "H." The Big O is rousting Lenny Bruce for maryjane and making him his sniveling snitch. Bird has flown off the bandstand and has been replaced by tenor sax king Dexter Gordon.

Dex is a six-foot-six mulatto with a billy-goat beard. He's a whole string of cars on a *loooooooooong* soul train.

He resembles a kold kat you'll see in a daily bulletin later in this book.

The scurvy skeezix pictured is your ultimate low-life hype. He's known to "play the saxophone." He "habituates pool halls and can be found at jam sessions." He lives off of women. He's an occasional pimp. He's a low substrata 459 man—an "acquaintance burglar."

He befriends people. He wins their trust. He acclimates himself to their pads and makes sure that their doors are left unlocked. He enters the pads while his friends are out and robs the fools blind.

The nomenclature of criminal activity fascinates and enthralls us. This is not 211 armed robbery or 187 homicide. This is the low-end, feed-your-arm, lazy-man hustle. You can laugh at it and still feel good about life on earth. *"Acquaintance burglar."* Nobody could make this up. *I* couldn't make this up. *Wait!!!*—isn't that *him,* right now?

Yeah, it is. He's hitting Miles Davis up for a handout, right there at a ringside seat. John O'Grady drops Lenny Bruce like a hot turd and takes off after the cat. Lenny's at loose ends. He sees me and sidles over. He says, "Hey, Ellroy. What's shaking, baby?"

I say, "Nuthin' but the leaves on the motherfuckin' tree."

An invigorating dialogue ensues. It's all bebop, boss bitches and our priapic prospects on this noxious night in L.A. '53. Lenny tells me there's a sneak peek at the Wiltern Theater. Dig it: Sterling Hayden in *Crime Wave.*

It's L.A.

It's '53.

It's film noir.

Of course—we've gotta go.

Bebop soundtracks this book. Film noir serves as our *sin*ematic subtext and kineticized visual cohort. Both genres deride authority and yet ride shotgun to a book that *honors* authority and extols America's most august police agency. Film noir has been overanalyzed and scrutinized as much as the LAPD. It's most immediate cinematic precedent is German Expressionism. It is allegedly a reaction to, and rebuttal of, excesses of the

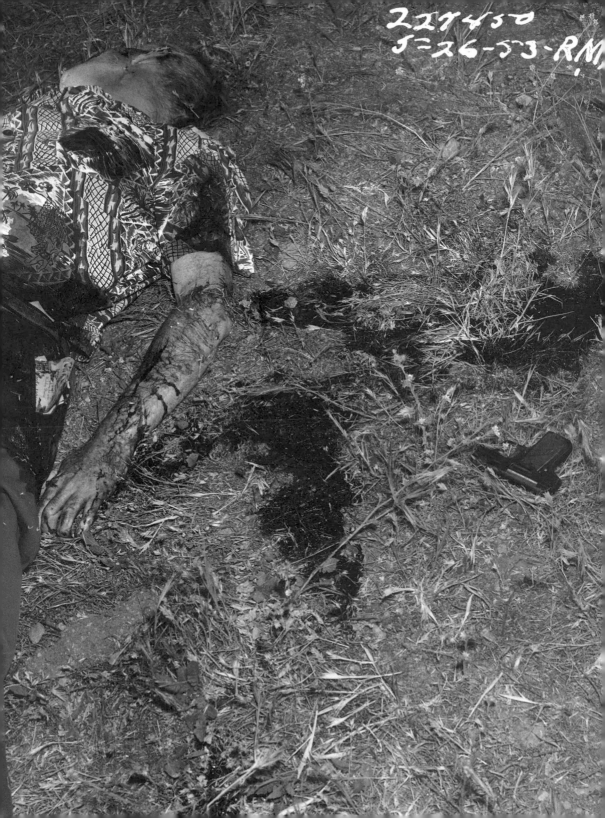

postwar Red Scare. The latter is both true and false and must be judged as philosophically self-serving. The Hollywood Ten pilloried is small potatoes when compared to Stalin's postwar purges and iron curtain aggression. Film noir is most tellingly a reaction to the 30-year transit of horror that began with World War I and lasted through V-J Day and the beginning of America's noble effort to resuscitate Europe with the Marshall Plan. 1953 found us 40 years into an all-new world terror. War, famine, totalitarian alliance, hundreds of millions dead. War profiteering, coups, overthrows, the A-bomb. Refugee film talent, adrift in Hollywood—many artists Jewish and left-wing. The Russian left betrayed them as Hitler rounded up and murdered them. Now, they're in Hollywood—working on cheap-o crime flicks and suffused with justifiably paranoid heebie-jeebies. The film studios are here. It's cheap to work on location here. The crime film has a built-in latitude that allows for social critique. Thus, film noir is primarily L.A.-based and oozes pervert

Suicide, May 26, Hollywood Hills

potential. Thus, any police film shot on location in L.A. is implicitly a film about the LAPD. Thus, this book targets film noir aficionados. Thus, this book is seamlessly compatible to film noir. Thus, five-year-old Ellroy and Lenny Bruce are jungled-up at the Wiltern Theater for André De Toth's *Crime Wave.*

De Toth had solid film noir cred. He was European. He lost an eye in a Nazi-Commie street brawl, circa '28, and wore a rakish eye patch. Sterling Hayden stars in *Crime Wave.*

Hayden was a onetime pinko. He ratted out fellow travelers to government committees and harbored unnecessary guilt. Said guilt did not stop him from going for the gelt in his portrayal of an LAPD bruiser.

Hayden's Lieutenant Sims is a vivid explicator of Bill Parker's mission of interdiction. He's maladjusted and vexed from a recent withdrawal from cigarettes. He's uncannily intelligent. His physical presence is on a par with many of the cops pictured in this book. Street presence promotes suppression without the use of force. The implied threat of "we'll kick your ass" carries more pop than asses kicked wholesale and packs a humanist punch that even pinkos and peaceniks can groove. The LAPD was an ass-kicking entity in 1953. The LAPD kicked *my* ass on three notable occasions in the late '60s and early '70s and stretched me onto the straight and narrow. Read these words and skim the photographs that follow this text. You may well make a startling connection. It may prompt you to wonder what came first: the chicken or the egg.

Were the police photographs collected in this book suggested by the film noir style, or was film noir a stylistic offshoot of cop pix?

Crime Wave suggests a reciprocal synchronicity. It was shot in '52 and released in '54. It's got that transitional look that so informs *LAPD '53.* The old L.A.'s getting a modernist makeover. Spaceship cars are on the rise, humpbacked cars are on the wane. Buildings are going low, flat and angular. Isolated structures stand out, juxtaposed against vacant lots.

Chinatown looks freshly painted and garishly redone. City streets look significantly wider than they do today. That's because of a scarcity of parked cars and passing motorists. *Crime Wave* bids the viewer to watch *this*—L.A.'s on the rise, and what you're seeing won't last much longer.

Crime Wave is our bebopped sister flick. It's as kinetic as *LAPD '53* is gorgeously static. The action carries us through nonstop days and nights. The film has a "hopped-up/fuck sleep/we're out to score" feel. It's all roadblocks, APBs, LAPD squadrooms. *Ooooooooooooh,* Daddy-O—the heat is on!!!!! Crashed-out cons are out to take down a Glendale B of A. The heist is masterminded by noted film noir greaseball Ted de Corsia. The hunky young Charles Bronson is Bad Ted's aide-de-camp. They need a skilled pilot to fly them down to Mexico, post-heist. Ex-con Gene Nelson fits that bill. Gene's shacked up with his she-wolf wife, Phyllis Kirk. He's a small-plane pilot trying to go straight. "Straight" doesn't quite fit Gene Nelson. He's a tad minty and seems unequal to the She-wolf. Nelson was a onetime Broadway dancer. That marks him suspect from the get-go.

Crime Wave abounds with psychopathic bad behavior. The great Timothy Carey chews scenery as a lunatic lech out to loin-lock the She-wolf. Lieutenant Sims lets the heist go down and busts it up in progress. Death reigns in the end. Sims cuts Queen Gene and the She-wolf loose to return to their shitty lives. He lights a cigarette, takes a drag and tosses it.

Ooooooooooooh, Daddy-O—there's that film noir rush! The ambiguous gesture, the futile undercurrent, the pervading knowledge that the whole game is rigged. Winner take nothing. No exit, baby. Film noir makes us smug even as it belittles our status as human beings. Who gives a shit? It's L.A. '53, and we're making the scene.

Crime Wave is a tight flick and a vivid visual toast to L.A. *Then.* It's the ultimate companion piece to *LAPD '53*—because it codifies period archetypes and gives you what the book can't.

Great police interiors.

The LAPD Detective Bureau at City Hall.

It's open all nite.

It's small compared to every other squad bay that you've seen in movies.

We tried to dig up archival squadroom shots—and failed. *Crime Wave* delivers the goods. André De Toth shot his film on the actual locations. Note the tightly pressed office spaces and low ceilings. Note the crammed-in desks and the welter of night creatures smooshed up on hard wooden benches. Groove it—there's *NO EXIT!!!!!* It's Whiskey Bill Parker's town, and your ass is fucking grass!!!!! There's Lieutenant Sims, played by six-foot-five Sterling Hayden. He's having a shit day. He's got the big bone for the She-wolf, but she just slinked off with her homo hubby. Sims is looking for a scapegoat punching bag—and *YOU* fit the bill!!!!!

It's film noir.

You're fucked.

The green room up at San Quentin calls your name.

Vous êtes *l'Étranger.*

You are Camus' *The Stranger*—striated and stripped bare. The gas chamber looms.

Why do we live for this shit?

In large part, it's this:

It allows us to time travel. We're back in a less circumspect time, constrained by rigid laws that we believe in but violate with a wink. Booze and tobacco are not yet demonized. Sex has not been overscrutinized, debunked and vulgarized past comprehension. We're hip, slick and cool. We're denizens of a private world within the real world. The constraints and moral censures of 1953 protect us. We're time travelers with the gift of retrospection. We know what happened in the end and feel securely at home. "Home" is film noir's fatalistic worldview—which condones our bad conduct, because the game is rigged. You can't go home again, but art allows us to linger. I'll never shack with the She-wolf at the Beverly Hills Hotel—but the photographs in *LAPD '53* place me within the context to dream.

Every photograph in this book is a flashpoint rendering of the chaos

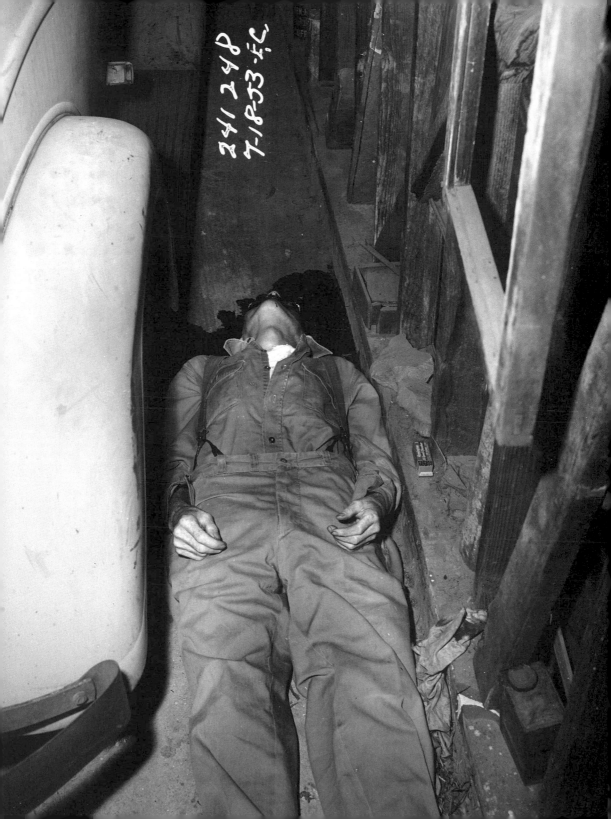

that Whiskey Bill Parker sought to suppress. Crime is a continuing circumstance. Our flashpoints are a daily occurrence. It's all juxtaposition.

Juxtapose *Crime Wave* against the LAPD propaganda vehicle *Dragnet*. The former gives us the proportionate topography of 1953. The latter gives us the language and buttoned-up professionalism of the LAPD, exactly as Bill Parker wished to see it portrayed. Cops spew penal code numbers. The number 459 connotes a panty-sniffing hot-prowl burglar, out to peep brassieres draped over a bathtub ledge. Maybe the lady of the pad is sleeping in the next room. The hot-prowl man can snatch her purse and catch a glimpse of skin. Of course, *Dragnet* left the good shit to your imagination. The number 187 connotes a stiff and demands the explication of motive. *Dragnet* seeks to render the pix in this book prosaic. *Crime Wave* renders them brutally poetic—because it provides us with the ever-vivid context of the time that *Dragnet* does not. We look at pictures because we've *looked* at pictures and we've learned *how* to look at pictures along the way. "Every picture tells a story" is bullshit. Captioned pictures provide perfunctory vignettes and urge us to turn the page. *Great* pictures urge us to create our own stories. Pictures depicting horror and pathos make us look once, turn away and look again. *Dragnet* was TV pabulum. It was moderately entertaining and whitewashed the menace and brute glamour of policework. Jack Webb's Joe Friday was a snooze compared to Sterling Hayden's Lieutenant Sims. You have a book in your hands. Stunning photographs are crying out, *"Look at me and ponder what this means."* Bebop, film noir, slinky she-wolves. What's the overall connection? It's art and sex in a time of stratification and repression. Bill Parker was our main man *Then*. He's keeping the L.A. streets safe—and in that capacity he's granting art and sex and the two commingled an astoundingly subversive power. Bill Parker's our main man *Now*. Art and sex are in the shitter, because subversion has been branded, Internetted and malignantly

monetized. Movies and TV shows are visual aids to help us more cogently appreciate still pictures. The converse equally applies. L.A. *Now* is vilely explicit. It's all safe-sex billboards and glittering light displays for alcoholic beverages and apocalyptic feature films. L.A. *Then* was elliptical and implicit. Look once, look away, look again. Compose a story as you view those feet sticking out from under that morgue sheet. Glimpse the swervy details of sudden catastrophe and the moment of police intervention. Pretend that you're viewing these pix in their historical moment. You cannot digitally alter, enhance, or denude them. Your sole options are look again or look away.

Newspapers taught us how to look *Then.* Evil deeds, bad behavior, snappy prose and pix. Newsprint pixels obscured details and whetted our appetite for high-contrast black and white. The L.A. *Times*, L.A. *Herald*, L.A. *Examiner* and *Mirror News.* Big local coverage. Crime stories serialized as breaking leads accrued. Jazzy murder cases recounted—from the time the body is found to the moment the killer sucks gas in the green room at Big Q.

Accompanied by news pix. Bodies tucked under sheets, with morgue tags hooked to big toes. Arrows pointing to death houses, pads, cribs, shacks. Stern cops attending hellhound fiends in extremis. What Don DeLillo called "the neon epic of Saturday night."

One crime ruled the L.A. dailies in 1953. Burbank caught the squeal and brought in LAPD for more muscle. We're bebopping back to 3/9/53. I've got the words, the LAPD archive's got the photos. That big black arrow is pointing to a pad on Parkman Avenue. It's the Mabel Monohan snuff.

You know this caper. It inspired the Hollywood weeper *I Want to Live!* Susan Hayward wins the Oscar. She burns in the green room for a crime she did not commit. Fuck that shit!!!!! Barbara Graham was a stone junkie and a stone killer!!!!! She deserved to fry!!!!! The wages of sin are death!!!!!

Here's the real gist. I am *not* speaking with forked tongue, readers! I am telling it like it is!

Issued Daily except Saturday, Sunday & Holidays by L.A. City Printing Bureau

Daily Police Bulletin

For Circulation Among Police Officers Exclusively

CHIEF'S OFFICE, City Hall (Phone MIchigan 5211 — Connecting All Stations and Depts.) W. H. PARKER, Chief of Police

OFFICIAL PUBLICATION OF POLICE DEPARTMENT, CITY OF LOS ANGELES, CALIFORNIA

Vol. 46 Friday, April 17, 1953 74

WANTED

ARREST FOR KIDNAPPING AND A.D.W.

(A Felony—Count 1) (A Felony—Counts 2 and 3)

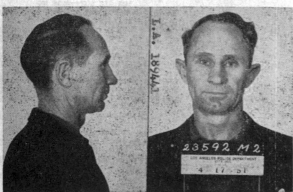

We hold Felony Warrant No. 114781 charging Kidnapping (a felony, count 1) and ADW (a felony, counts 2 and 3) for the arrest of **EMMETT RAYMOND PERKINS**, alias **JACK BRADLEY.**

L.A. No. 189441; F. B. I. No. 149473; C. I. I. No. 310B181; S.Q. No. A5015-44811; Folsom No. S17624-18826.

Description: 44 yrs., 5 ft. 9 in., 140 lbs., blue eyes, brown-grey hair, false teeth which he frequently carries in pocket.

Fingerprint classification:

Suspect No. 1 Full set fingerprints

$$\begin{array}{ccccccc} 20 & O & 21 & - & IIO & 16 \\ I & 1 & U & & IIO & 13 \end{array}$$

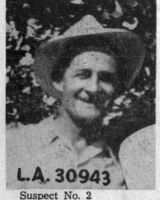

L.A. 30943

Suspect No. 2

(Left Middle Finger)

$$\begin{array}{ccccc} 31 & - & IO & 19 \\ 18 & R & OI & 15 \end{array}$$

Subject kidnapped victim at gun point and forced victim to accompany him in a 1950 or 1951 Dodge or Plymouth Coupe, grey in color, license unknown. Victim's wife was eye witness to kidnapping and positively identified subject. Believed to have been driving car is suspect No. 2, John Albert Santo, aka Jack Santos, Jack Mahoney, L.A. No. 30943; described as: M.W.A., 48 yrs., 6 ft. 1 in., thin bald, grey or blue eyes, dark brown hair, greying at temple, sometimes colors hair, wears Van Dyke or full beard on occasions—suspects may also be driving a 1925 Olds. 98 two-tone green, license No. 8L4 587. Victim is Baxter M. Shorter, M.W.A., 43 yrs., 5 ft. 9 in., 175 lbs., dark hair and eyes, wearing grey trousers, checked wool grey shirt. Subject Perkins has brother, R. M. Perkins, residence 3195 Gardena, San Bernardino. Mother, Ora Lancaster, 1074 Bobitt Drive, San Bernardino; sister, Mrs. A. W. Countway, 10930 E. Bayse, El Monte; wife, Lora Perkins, 1278 W. 127th Street.

Mabel Monohan was yo old gray-haired granny. Her son-in-law was an L.A./Vegas gambler named Tutor Scherer. A bullshit rumor circulated throughout the underworld. Said rumor: Mabel Monohan always held a hundred G's to help the cat out of scrapes. It was apocryphal jive and urban legend. But two vicious slime-bags named Emmett Perkins and Jack Santo believed it.

These cocksuckers were as evil as evil gets. They were strongarm 211 men and coldhearted killers. They went on a spree in the gold country, up near Sacramento. They slaughtered a local family for six grand in grocery store receipts. Dad, mom, three children. One kid survived. Perkins and Santo shot them and dumped them in the trunk of dad's car.

Perkins and Santo—evil mother-fuckers. Now, they're hipped on Mabel M's hundred G's. *That's* a score—and they've only got to snuff one old lady to get it.

The humps round up a home-invasion gang. There's a deep sea diver on the skids named John True.

There's a 211 pro named Baxter Shorter. Perkins and Santo are jived-up with a hype/ho/gang cooze named Barbara Graham. *Oooooooooh*, my rasty readers—she's got fallen-patrician good looks, a calculating hophead mien—and she probably wears high black boots and nothing else with Dorothy Malone panache!!!!! Oh, yeah—five-year-old Ellroy's got it *baaaaaaaaaad* for Bad Babs!!!!!

Here's the plan:

Babs knocks on Mabel M's door. She acts distraught, reports a traffic accident and asks to use the phone. The good-hearted Mabel opens the door a crack. The muscle boys crash in.

It's cake from there on. They squeeze Mabel. She forfeits the gelt. They kill her and get away clean.

Yeah, it seems sound. But—there's no gelt. It's a zero-sum proposition.

Mabel opens the door. Barbara Graham ladles on the boo-hoo. Our boys crash in behind her. Mabel delivers the dish: there's no hundred G's.

Babs pistolwhips her. Santo and Perkins beat on her. Baxter Shorter

and John True look on, horrified. They weren't up for *this*.

Shorter flees. He splits to a pay phone and calls an ambulance. He reports an accident and mistakenly spiels the wrong address. Mabel Monohan dies. The gang disperses. Burbank PD grabs the squawk. LAPD provides backup. A massive manhunt begins.

Underworld informants come forth. *This* crime horrified a slew of low-tide losers eager to violate gangland snitch codes. The cops clock that hundred-grand rumor and soon peg it as the source of the crime.

And—the grapevine's buzzing that two plug uglies have been talking up a Mabel Monohan score. Their names: Emmett Perkins and Jack Santo.

An APB goes out.

Perkins, Santo and Bad Babs go underground.

The fuzz grab John True and Baxter Shorter. They turn snitch and blab state's evidence. Perkins and Santo kidnap Shorter from his pad on Bunker Hill, drive him to nearby mountains and whack him. Tips flood the Burbank PD and LAPD switchboards.

One proves valid. Cops raid a nearby lust nest/hideout. Perkins, Santo and Bad Babs are caught in a thigh-throbbing threeway!!!

The case is a *sin*sation. It gets huge ink and local TV play. Barbara Graham nests in stir and launches a hankie-holding campaign to save herself from the green room. It better work, sister—J. Miller "Gas Chamber" Leavy is prosecuting the case for the L.A. D.A.'s Office. He's the Kapital Kase Kahuna—and he comes to win.

There's the prelude to the trial. Bad Babs waxes weepy and protests her innocence. She's got a little boy from an absentee marriage. *He's* good for beaucoup boo-hoo. Behind-the-scenes machinations begin.

LAPD brings in a rookie cop to soft-soap Babs and get her to admit Murder One. He's a handsome, heavy-hung Harry—just Babs's type. No soap—Babs don't dish shit. The fuzz fear that Babs will get pregnant, in an effort to thwart the hot seat. Any and all men visiting her are carefully monitored. It's rumored that Babs goes lez in stir. A bitchin' babe fighting a drunk-driving beef is enlisted to seduce and entrap her. Racy napkin notes bounce back and forth in the women's jail. Alas—there's no Sapphic seduction, no furtive footage, no audiotape and no snitch. Barbara Graham, Emmett Perkins and Jack Santo go to trial.

Hear those low chords pop pianissimo? It's the funeral march from Chopin's Second Sonata. J. Miller Leavy's coming in for the kill.

The trial proceeds. It's a rout. Graham, Perkins and Santo are convicted and sentenced to death. The green room wails their names.

Babs sticks to her innocent-woman-wronged tale. She mainlines public sympathy. Her little boy is a great P.R. foil. San Quentin, death row, protracted appeals. The green room on 6/3/55.

Babs admits her guilt to Warden Harley Teets the preceding night. Perkins holds his shit. Sissified sinner Jack Santo bitch-squeals fo his momma.

Aaaaaaaaaahhhhh—the pellets drop. *Aaaaaaaaaahhhhh*—that burnt-almond smell and exsanguination.

The wages of sin are death.

It's the ugliest crime story I know. Check the police bulletins reprinted in this book. Scrutinize Graham, Perkins and Santo. Read their faces. Look for indications that they possess such sheer cruelty. Read their *eyes*. You'll see nothing but attitude and emptiness. You're looking at the cold heart of L.A. '53.

But hurt hearts, hot hearts and hard hearts pulse more prominently in our *Pueblo Grande*. It's the throb of the boomtown masses. It begets epidemic opportunism. L.A.'s building up and out. The San Fernando and San Gabriel Valleys are exponentially increasing growth zones. Pastel-painted hotbox huts and faux ranch houses—more and more built every day. No down payment. G.I. Bill loans. Returning World War II and Korean War vets hitting L.A. in swarms. The two valleys run heat-hazed and humid. These cheap new cribs absorb and trap heat. Sometimes that heat gets to you and unleashes this *kraaaaaaazy* jungle juju. A cat named Fredericks chops up his wife and buries parts of her in his backyard. He dumps the bulk of her in the trunk of his car and takes his kids on vacation. They know that momma's missing, but they don't know that she's closer than they think. Dig the photo spray in this book. Note the cops wielding shovels in their shirtsleeves. Note the *size* of the pad. It's roughly the dimension of a POW camp sweatbox. It's the same size and same style as the cribs all around it. No down payment. Easy credit terms. It's a compression cave. The Korean commies are shrieking gobbledy*GOOK* and want you to repugnantly renounce the U.S.A. Your old lady's jabbering in the next room—and you start thinking *KNIFE*. L.A.'s an opportunist's zone. Murder feels like an opportunity. The walls are closing in on you. It's fucking hot. The houses all around you look just like yours. You could chop her and get away with it. You watch *Dragnet* every Thursday night. You know how the L.A. cops act and think. You know you can fool them.

The valleys are *hot*. The L.A. opportunities are *hotter*. Fuddy-duddy Mayor

Daily Police Bulletin

For Circulation Among Police Officers Exclusively

FICE, City Hall (Phone MIchigan 5211 — Connecting All Stations and Depts.) W. H. PARKER, Chief of Police

PUBLICATION OF POLICE DEPARTMENT, CITY OF LOS ANGELES, CALIFORNIA

Tuesday, April 21, 1953 No. 76

POLICE COMMISSIONERS
N F. SELVIN, President
NDER SOMERVILLE, Vice-Pres.
ETT C. McGAUGHEY
HUGH C. IREY

TOLEN CARS
April 21, 1953
r. Make Model Motor
9 Plym Coupe P94859
0 Ford Sed BOLB121172
Merc Mntrey 50LA41628M
Linc Cosp Spt Cp 53LA6860H
ATES:
25 1N14 436

ST FOR FORGERY
(4 COUNTS)

elony Warrant No. 2482,
gery (470 P.C.), (4 counts),
of **GEORGE PAJU**. L.A.
B.I. No. 4212072. Bail $1,500.
W.M.A., 31 yrs., 6 ft. 2 in.,
blond hair, combed straight
es, round face, fair com-
nian or Finnish descent.
Ford convertible, white in
ia license 4A95331.

ight Index Finger
classification:
22 M 17 — IOO 15

ARREST FOR PETTY THEFT WITH PRIOR CONVICTION OF A FELONY
(3 COUNTS)

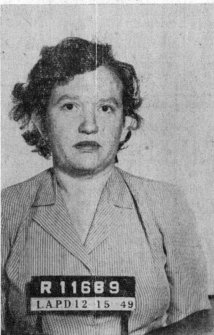

R 11689
LAPD 12 15 49

We hold Felony Warrant No. F-2224, charging Petty Theft With a Prior Conviction of a Felony, (3 counts), for the arrest of **CATHERINE GLENN**, aliases **CATHERINE WILLARD, OLIVE WEIR, KAY GRAY, KAY MORRISON**. L.A. No. R-11689; C.I.I. No. 200977; Tehachapi No. 1004. Bail $1,500.00.

Description: W.F.A., 34 yrs., 5 ft. 0 in., 130-140 lbs., reddish brown hair, brown eyes, pock marks right forehead and left chin, prominent ears, freckles on face. Appears to be 7 or 8 months pregnant. Often dresses in all white crinkle uniform with saddle type shoes.

R# 11689

Right Index Finger
Fingerprint classification:

ARREST FOR ISSUING CHECK WITHOUT SUFFICIENT FUND
(7 COUNTS)

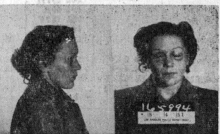

We hold Felony Warrant No. 114832, charging Issuing Check Without Sufficient Fund, (7 counts), for the arrest of **BARBARA GRAHAM**, aliases **BARBARA DIANE GRAHAM, BARBARA ELAINE KLEIHAMMER, BARBARA KIELHAMER**. L.A. No. 165994; F.B.I. No. 2252109; C.I.I. No. 147337; San Diego P.D. No. 14077. Bail $5,000.00.

Description: W.F.A., 29 yrs., 5 ft. 3 in., 125 lbs., brown hair and eyes, neat dresser.

Right Index Fingerprint
Fingerprint classification:
 11 S 1 R I OOO 12
 S 1 R I OOO 11

Subject wrote a series of no account checks, signing them Barbara Graham, and obtained merchandise and cash by passing them in department stores, cocktail bars, and with doctors who had treated her 14 months old son, Thomas Graham. She may be traveling with John A. Santo, alias Jack Mahoney, L.A. No. 30943, W.M.A. 48 yrs., 6 ft. 1 in., thin, bald, dark brown hair, greying at temples; and Emmett Raymond Perkins, alias Jack Bradley, L.A. No. 189441, F.B.I. 149473, W.M.A., 44 yrs, 5 ft. 9 in, 140 lbs., blue eyes, brown-grey hair. Santo and Perkins are wanted for Kidnapping and A.D.W., the victim being Baxter M. Shorter, W.M.A., 43 yrs, 5 ft. 9 in., 175 lbs., dark hair and eyes. Refer our daily Police Bulletin, No. 74 of April 17, 1953.

Suspects may be traveling in a 1952 Oldsmobile 98, two-tone green, license No. 8L4587. USE CAUTION IN APPRE-

Fletch Bowron is *out*. Gladhanding growth czar Norris Poulson is *in*. There's talk of major league baseball teams to oust the Gilmore Field bush leaguers. There's Wrigley Field down in darktown—a mingle zone for Whitey and the Black Man. Colored folk stick to themselves, whatever their color. Negroes stick south of Washington Boulevard and east of the U.S.C. campus. Mexicans inhabit Boyle Heights, Lincoln Heights and far-flung Pacoima. The Japanese are more widely assimilated—despite their status as our World War II foes. This suits Whiskey Bill Parker— because it serves the greater good of the ordered society. The emerging L.A. freeway system is hemming it all in. We're two freeways in, with many more slated to go. The Arroyo Seco has been running since '40 and links downtown to Pasadena. The just-completed Hollywood Freeway links downtown to Hollywood and bleeds into Route 101 northbound. "Bleed" says it all. Freeway systems are handy escape routes for hit-and-run armed robbers and all criminals of the smash-and-grab/go-in-hard-and-stupid school. Freeway on and off ramps are nesting spots for winos and body-dump spots for itinerant killers.

There's the issue of elevated perspective, as it pertains to this book. There's L.A. *Now*, there's L.A. *Then*. More-recent crime scene pix feature the classic freeway overpass shot of a dead dude splattered on the pavement. You don't get that in the L.A. *Then* of *LAPD '53*. We're dealing with flatland and hillside L.A., linked by surface streets. The relative absence of freeways explains the lack of zoom-lens, wide-angle, high-vantage-point, Hollywood-Sign-in-the-background art pix in this august volume. We're in tight. The photo framing replicates the L.A. of the time. We assume limit-less growth, we've engaged the concept, we know we've got growing room. There's valleys to populate, mountain ranges to plunder, slum-land to bulldoze. All that is *horizontal*. Don't forget the *vertical*. City Hall is the tallest building in L.A. '53, and it's no skyscraper. That's why growth czar Mayor Norris Poulson is always smiling

that year. He knows that L.A. will get a major league ball club sooner or later—but he doesn't know that he'll have to pull a huge landgrab and evict impoverished Mexicans in order to break ground for the home field. Whiskey Bill Parker is always smiling in '53. Why? He's got L.A. right where he wants it—which is exactly the way it is *Now*—back when *Then* was *Now* and there was no *Then* and *Now* between '53 and '15. It was Whiskey Bill Parker's town, and we just lived in it *Then*. Now, it's 2015—and Whiskey Bill's 48 years *muerto*. And L.A. *Now* is beyond cosmetic repair and control— while L.A. *Then* is a wiggy land of naiveté, beauty and stratification.

Nostalgia. You indulge the practice for all the right and wrong reasons.

Police nostalgia.

Why are pictures of dead people at crime scenes so beautiful?

Because they're always somebody else, and it's unlikely that *we're* going to get shivved at a flophouse on East 5th Street. Because the accretion of filmic detail suggests a world both akin to and apart from our own.

Because the subconscious roils with buried images and synaptic fragments culled from racial memory and our lifetimes aswirl in the ever-evolving *spiritus mundi* that we call History— and to touch the borders of horrific life *Then* affirms our own earthly transits of *Now*, as it reaffirms them as both luminously unique and flat-affect banal—because in the end we are all united as one being possessed of one soul, and in the end art is the merger of the living and the dead, enjoined in reconciliation.

I believe that the theocratic William H. Parker would have understood this metaphysic. I believe that he likened his LAPD stewardship to that of a Utopian ruler—all the while knowing that said Utopia would ultimately ripen, soften and decay into the ever-expanding, overpopulated, billboard-blighted shithole that is L.A. *Now*. Parker saw the beginning of the descent and erroneously chalked it up to rowdy black folks enlivened by dope, watermelon and rebellion. He made petulant and intemperate remarks, racist by all sane standards,

and permanently besmirched his sterling legacy. William H. Parker was *Il Gattopardo*—L.A.'s equivalent of the Sicilian patriarch in Guiseppe di Lampedusa's novel and Luchino Visconti's film. The Leopard's world changed out from under him. There was always trouble in paradise—and he superbly interdicted and suppressed it. Sicily, 1830. L.A., 1953. It was Bill Parker's town. We just lived in it. And in those early days of Parker's reign, the entire populace lived swaddled in properly militaristic and patriarchal safety. Crime is a continuing circumstance. Crime is individual moral forfeit on an epidemic scale. The crimes so artfully pictured on

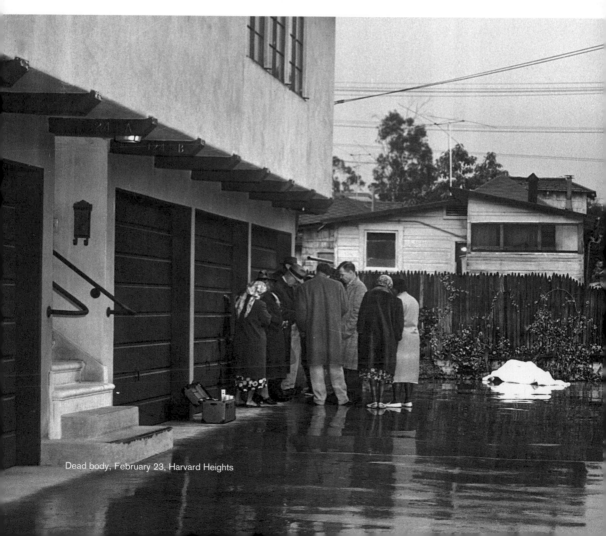

Dead body, February 23, Harvard Heights

these pages are equally balanced between rank predation and heartbreaking human folly. William H. Parker was a heartbreakingly stern and rigid man with the grandiose and chaotic inner life common to drunks. He accounted himself only to God and lacked the earthly quality of pity. This vacancy buttressed his astonishingly fierce devotion to task and blinded him to the portents of change swirling all around him. His tragic flaw was inextricably linked to the source of his greatness. William H. Parker would have admired the cold proficiency of the photographs in this book. William H. Parker would deride their sad humanity.

Our photographs largely depict low-rent L.A. and the sad demography of trouble in paradise. The viewer must supply the expanded context of Greater L.A., buffed and gleaming. The streets were wide. There was no bumper-to-bumper traffic to blitz egress and spatial perspective. The Spanish colonial building style predominated. The lack of tall buildings made the bright blue sky fall flat, in the manner of Bill Parker's native South Dakota prairie. The Pacific Ocean and a long mountain range enclosed us to the west and north. The south and east were nothing but sheer exploitable land.

My mother first saw L.A. in 1938. She was wowed by it and thought she might be happy here. She was murdered in L.A. 20 years later. William H. Parker died eight years on. *Ciao, Gattopardo*. We all owe you more tears than you shall see us pay.

The funeral line ran hundreds of cars and at least two miles long. It was 1966 and a new *Then* much different than the 1953 *Then* of this book. I watched the hearse move westward on Wilshire Boulevard. I was 18 years old. Wilshire still sparkled but did not quite gleam.

LAPD was out in force. There were thousands of blue uniforms. A great many American flags swirled.

Time toss. 1953, 1966, 2015. Pictorial history as a shared stream of consciousness. The blue forge. The red, white and blue. Progress brings devolution. It may yet create a fresh wave of interdictive constraint. Only our one soul united remains. †

Homicide, July 19, Watts

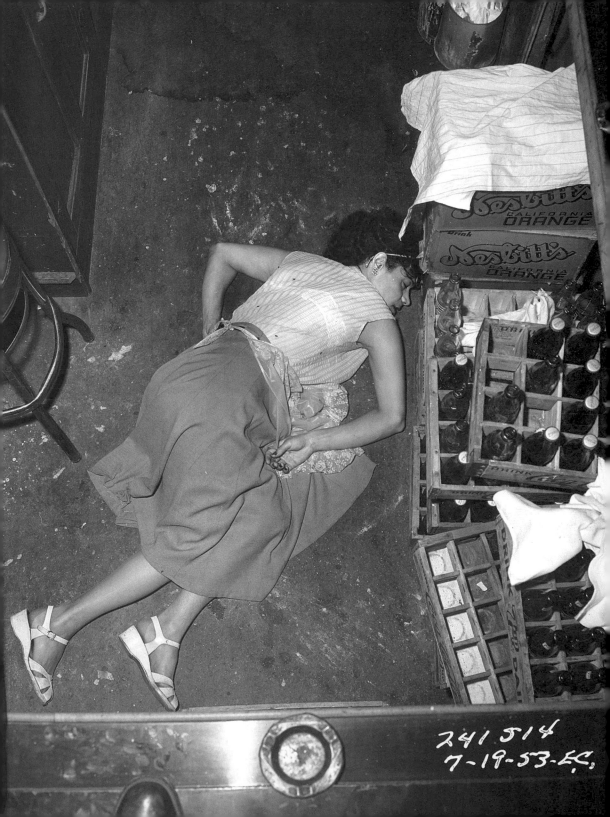

341 514
7-19-53-EC

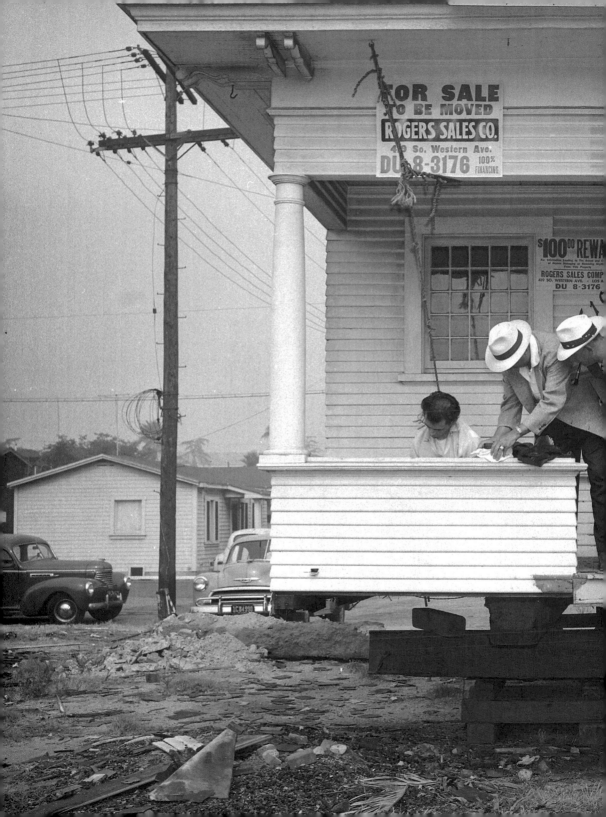

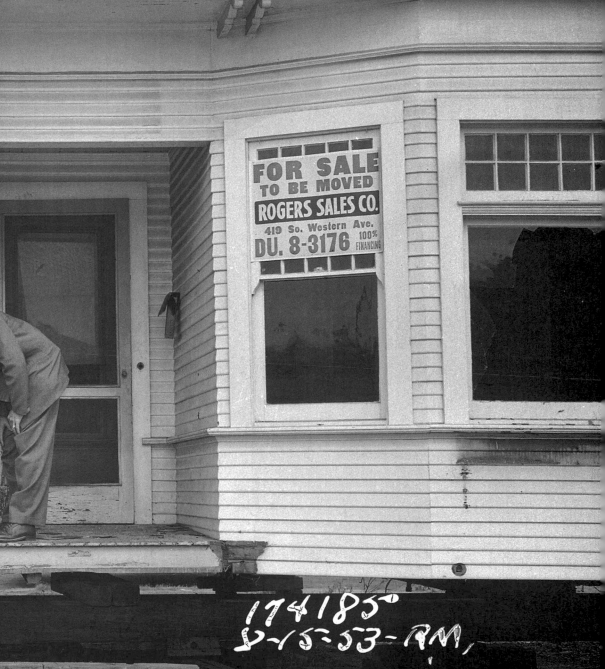

Suicide, August 15, University Park

BOARD OF SUPERVISORS BEEF

Here's a change-up pitch. It's a welcome relief from all our preceding gore. We're inside the chambers of the L.A. County Board of Supervisors. Note the dark wood and marble, the kids' Christmas drawings on the walls—holdovers from the '52 holiday season. They backdrop strange juju on 3/5/53.

It started with a zoning hearing in the Hall of Records. Mr. Sam Emerson and his wife requested a zone change for their subdivision in the far-flung L.A. County hamlet of Palmdale. Their request was denied by a vote of four to one. That one pro-Emerson vote was cast by Supervisor Raymond V. Darby. Yeah, Supervisor Darby thought that the Emersons were within their legal rights—but he told Mr. Emerson this:

"All you want to do is sell this land to a lot of suckers."

Emerson demanded an apology.

Darby refused and said, "Well, I think you're a nasty person."

Emerson launched a right hand and clipped Darby on the chin. Darby teetered, but did not fall.

Bailiffs seized Emerson. Darby made them release him. Darby went to his office and began breathing hard. He soon collapsed, unconscious. Two firemen were summoned and administered oxygen. Darby was wheeled out on a stretcher.

The man had a history of heart disease and a bad case of arterial sclerosis. Mr. Emerson's blow most likely sent him into a state of extreme agitation and shock. He died in the hospital later that day. A coroner's inquest ruled Darby's death to be homicidal. Legal proceedings were mandated. Emerson was ultimately exonerated.

Palmdale now houses 157,000 dusty souls. It was a desert dump *Then*. It remains one *Now*. †

MARCH 6

SHOOTING INTERIORS

Here's a twosky—both from November '53. We've got close-quarters gunfire at two locations, both fleabag hotels—one in East L.A., one in Hollyweird.

The East L.A. job was out of Narco Division. Detectives K. C. Soderman and Robert Conrad were prowling the premises of 2055 East 7th Street. They were searching for dope stashes among the hotel's residents. A male Mexican named Edward Gonzalez aroused their suspicion. They found two pieces of white cotton—common dope fiend paraphernalia—in his shirt pocket, along with a cap of Big "H" wadded into a chewing gum wrapper.

Gonzalez said, "I got to see my wife and kids." He shoved Soderman and took off running. Soderman and Conrad yelled for him to halt. He kept running. Conrad's gun discharged and sent a shot into Gonzalez's side. Gonzalez hit the floor. The bullet sluiced through him and hit the wall.

Soderman called for a meat wagon. They ultimately booked Gonzo and two more male Mexicans on suspicion of State Narcotics Code violations.

It was an in and out, clean caper. *It's 1953.* That was *Then.* The world was cleaner than it is *Now.* A minor dope bust, a single shot fired. The fleabag hotel looks uncommonly clean. A police detective is showing where that one bullet hole from a minor dope bust hit the wall.

That's thorough. That's conscientious. That's *sincere.*

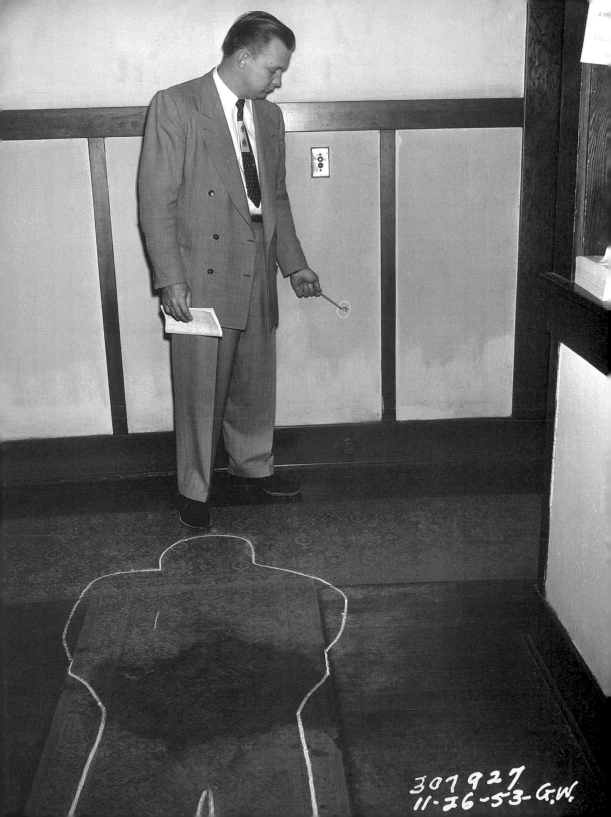

307927
11-26-53-G.W.

Our sister photo shows the upshot of close-quarters grief at Hollywood's dog-dick Padre Hotel. A squawk hits the Hollywood Station switchboard. A man is threatening his estranged wife on the premises. Detectives Clay Hunt and William McRoberts are sent to investigate.

Psycho estranged husband Robert Stewart attacks them on the dark second-floor hallway. He pulls a roscoe and zings out several off-the-mark shots. Hunt and McRoberts fire back and nail Stewart in the arms and neck. Check out *this* foto: A detective and two patrolmen are marking bullet holes on a wall.

Stewart was rushed to County General and held in the jail ward. He talked to LAPD Detectives A. W. Hubka and J. E. Barrick before he kicked. He told them he did not intend to harm his wife—only to shoot himself in her presence. †

NOVEMBER 26 & 11

FREDERICKS

We're back to that "walls-are-closing-in-on-me" job. Richard and Ruth Hilda Fredericks had three kids. Richard was an office clerk. Ruth Hilda stayed home and tended the rug rats. The marriage went bad in the classic ticking-time-bomb manner. Ruth Hilda split and got a cocktail-waitress gig. That was September '52. She spent a short interval out of the crib and foolishly returned. A doctor from Richard's place of employment huddled with her, concerned. Fellow employees reported that Richard had been acting strangely. One of them found a gun in his locker. Ruth Hilda and the doctor conferred. Ruth Hilda dropped a dime on Richard and had him committed to the psycho ward at L.A. County General Hospital.

Richard did a quick observation jolt and was cut loose. Tick, tick, tick. The walls are closing in. Now, it's January 7, '53. Richard Fredericks could not take it one moment longer. He picked up a croquet mallet and beat Ruth Hilda dead.

He cut off her hands and buried them in the backyard.

He dumped Ruth Hilda's handless body in the trunk of his car and drove south to Mexico. He took his kids with him. He dumped Ruth Hilda in a gulch off the Ensenada coast road. Ruth Hilda remained there, tagged as a Juanita Doe. A sharp-witted neighbor found Ruth Hilda's absence fishy and tattled Richard to a pal on the LAPD. Richard had driven his brood to his mom's place in Maplewood, New Jersey, in the meantime. LAPD launched a missing persons investigation. A detective was working a Jersey-based lead on another job at the time—and had Richard escorted out his mom's pad by the New Jersey cops. He did not suspect Murder One. He expected reticent Richard to

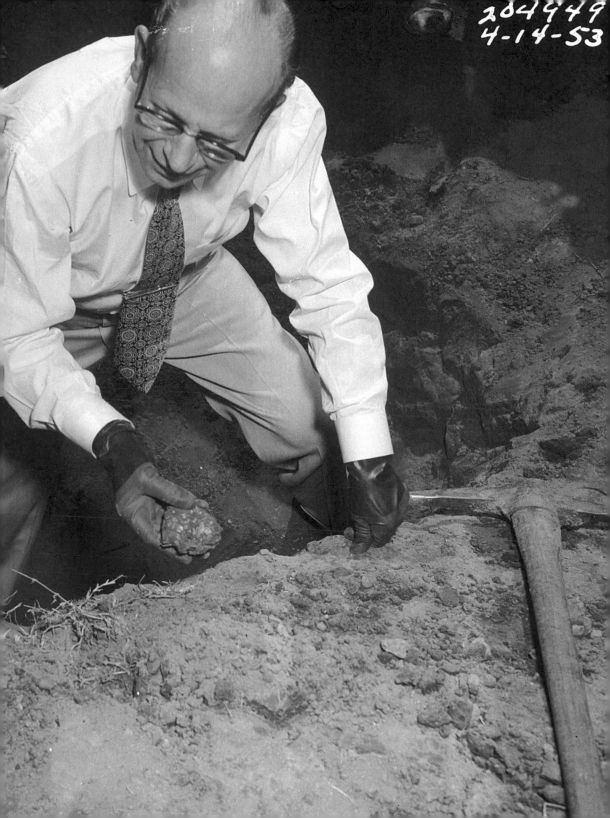

remain reticent during his visit to the local hoosegow. *Richard* revealed the deadly details—and immediately confessed the snuff as self-defense.

J'accuse, J'accuse—at trial he claimed that Ruth Hilda went after him with a kitchen knife. The jury bought it. Richard was sentenced to one to ten years in prison. *That* was a rank injustice! *And*—he got a soft berth at Chino, where soul sax Dexter Gordon jammed regularly with other dope-jailed jazz greats. The Fredericks job was a gas chamber bounce if ever there was one! I can only attribute the namby-pamby sentence to misguided empathy on the judge's part. He was probably prone to night sweats and visions himself. He probably knew that walls-closing-in-on-you gestalt all too well. †

APRIL 14

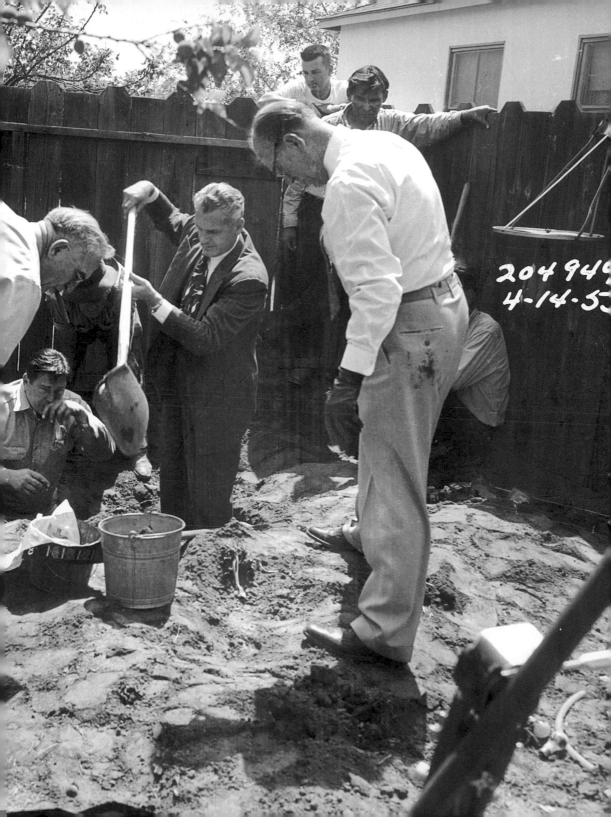

204 949
4-14-5

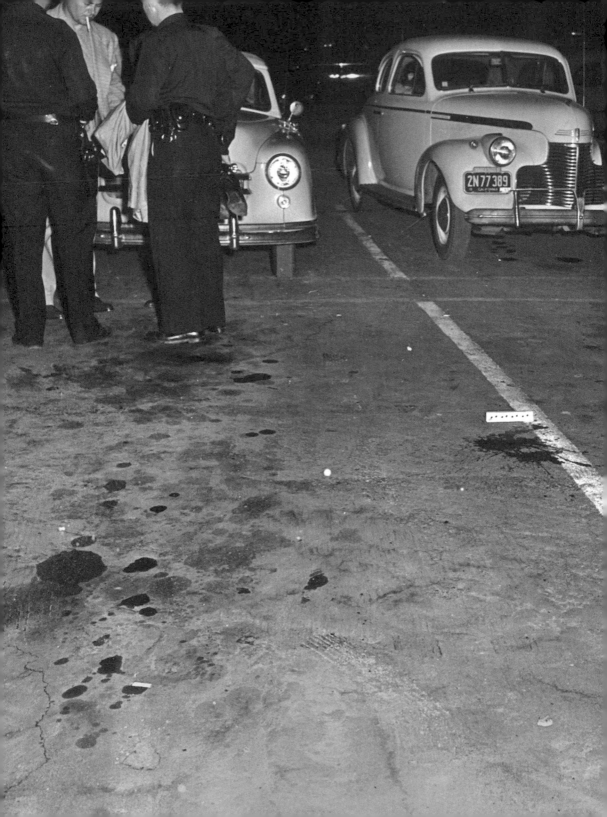

TRIANGLE

The eternal triangle. The *infernal* triangle, in this case.

Our crime occurred on 7/17/53 and left all three points of the triangle *muerto*. It's a psycho cop scenario with those peeper overtones so dear to my heart. The location was the Veterans Administration Hospital parking lot in West L.A. My dad kicked at the V.A. Hospital in '65. I was 17. Dad's last words to me were, "Try to pick up every waitress who serves you"—a legacy that I have fulfilled with mixed results.

Back to 7/17/53. It's nite. Our tragic troika is converging. Our licentious lover boy is Eugene J. Henry. The straying frau is Harriet Alden. The peeper-gunman is a Valley Division traffic officer named Don M. Alden.

Ooooohhhhh, Daddy-O—five-year-old Ellroy's got a jive-jumping jones for this dame—she's dark-haired, wears glasses and could surely dispense the spanking that this tumescently torqued toddler so richly deserves!!!!! Too bad, Ellroy—she's sitting in a parked car with her beetle-browed boyfriend, and Don Alden—*in his LAPD uniform*—is creeping up on them in the dark.

He gets to the car. He aims his service revolver in and fires. Eugene Henry is instantly killed. Harriet takes a head shot, gets out and runs toward the administration building, with her hopped-up hubby in hot pursuit.

He corners her. He kills her and kills himself. It made the papers for a mystical microsecond and quickly faded out. Whiskey Bill Parker probably pulled strings. *Dragnet* was his propaganda baby *Then*. This pile of postulant publicity surely gored his goat.

Three dead in a hot heartbeat.

Harriet and Gene might not even have been lovers. Intent and vibe do not constitute adultery. We'd all be mortally fucked if they did. †

JULY 17

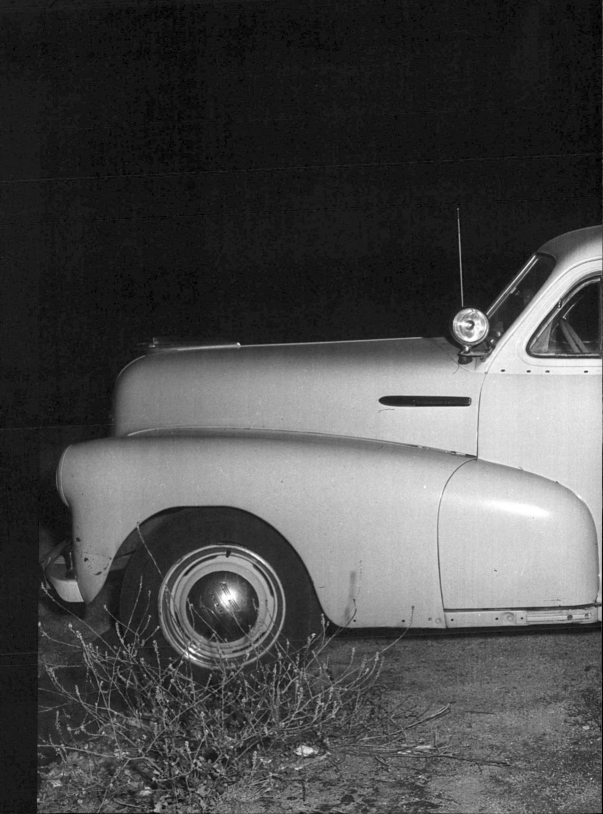

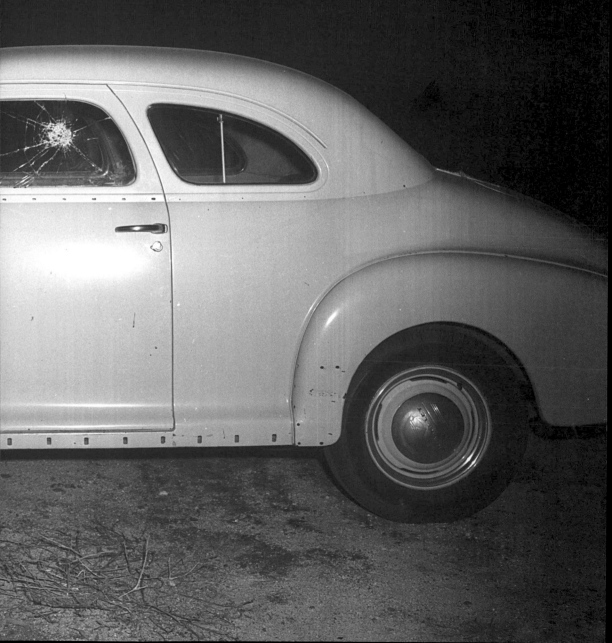

PEEPER

Ralph T. Avery was a hot-prowl man. He peeped, he prowled, he surveilled, he surreptitiously entered. He targeted houses occupied by unmarried women—career girls' cribs where young females lived alone or jungled up to save bread on rent. Hot-prowl men are snarky sneak thieves and pulsating pervs. B&E is a sizzling sex kick for these freaks. They're burglars at base. They often graduate and become full-time rape-o's. They prowl by nite and shamefully shatter the sanctity of peaceful abodes. L.A. by nite is their refuge. They live in sexual urgency. They're low-tide predators. Forty clams in a woman's purse is a *biiiiiiiiiiiiiiig* score. Maybe there's soiled panties in a hamper. Maybe there's fenceable jewels. Maybe there's a young ginch sweet enough to *take*.

LAPD had Avery under surveillance. He lived in Holly*weird*, in a perv pad near Melrose and Wilton. The cops suspected him of a score of 459/sex assaults. They ran spot tails on him and watched him case pads on the verge of L.A.'s southside. He finally hit a house at 2714 South Normandie. Three sisters lived there: Shirley, Lucille and Catherine Farrage.

Avery found a ladder in the backyard. He placed it under a dining room window and entered the house. LAPD Detectives J. E. Barrick, W. L. Jackson and L. G. Kohler watched from outside. Avery flashlight-prowled the house. He stayed inside for a short spell and came back down the ladder. The cops yelled out for him to *HALT!*

The *puto* perv *BOLTED*. He vaulted a fence. The cops knocked down the fence in pursuit. Avery leaped another fence, hotfooted it and made for a neighboring driveway. The cops opened fire and nailed him. Avery went down face-first. Let's reprise the great Don DeLillo's line. Avery died as a bit player in "the neon epic of Saturday night." †

OCTOBER 4

291751
10-4-53-R.R.

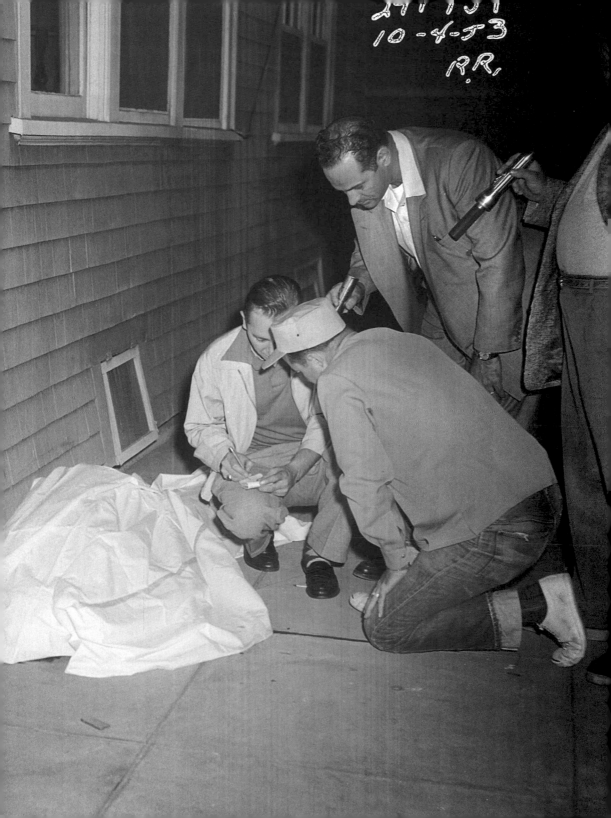

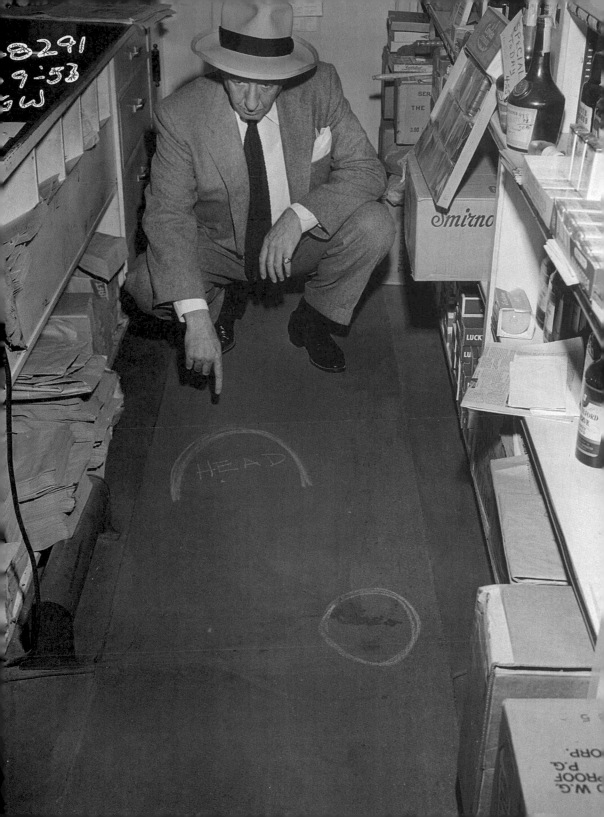

HEAD

HANSEN/LIQUOR STORE

Here's a rough one. There's one ray of hope. Sergeant Harry Hansen's on the job. That's him pointing to the chalk floor outline and the single word "head."

Hansen was the lead detective on the celebrated Elizabeth Short/Black Dahlia case of January '47. *That* case remains unsolved and hovers as Hansen's idée fixe. He's a great detective. If *anyone* can solve the Dahlia snuff, it's Homicide Harry. Now, it's 6/8/53—and he's got a fucking hybrid baffler.

It's a strong-arm liquor store 211/187 homicide. The robber-killer's still at large. Here's the gist—off the record, on the Q.T. and *very* hush-hush.

The liquor store is situated at Olympic Boulevard and Alvarado. The area was run-down in 1953—but it's a third-world hellhole *Now*. Note the interior photos. The store sells rotgut juice. There's Gallo Muscatel, Regal Pale and Eastside Old Tap Lager beers.

There's also nutritious corn chips, candy bars and salted nuts on sale. The proprietor/victim is a man named Joseph James Reposo. He's a white male American/age 73.

The caper went down on 5/29/53. Reposo was behind the counter. The presently unknown suspect entered the store and asked him for a bottle of scotch. Reposo proffered a jug. The suspect said it was too expensive. Reposo turned to grab a cheaper bottle. The suspect hit him from behind several times. Reposo slumped to the floor, unconscious. He would later describe the suspect as:

White male American/40 to 45/ 5′ 9″, 145 lbs, sandy hair. Clad in light gray suit/gray hat.

Reposo was discovered behind the counter a half hour later and was rushed to St. Joseph's Hospital. The suspect glommed $25.51 in cash register cash, $61.00 in wallet cash,

Reposo's pocket watch and an elk's head watch chain.

Reposo was interviewed at the hospital. He looked at a large run of mugshots and did not see the suspect. He stated that a blonde woman loitered in the store on the two days preceding the robbery. She was a white female American/about 28/5′ 2″, 110 lbs. Reposo thought she might have been casing the store and booted her out. Officers led him through a female mug run. Reposo did not see the blonde.

Joseph James Reposo died on 6/8/53. His watch was pawned at Cecil Loan on 6/23/53. The pawner supplied an obvious pseudonym. He signed a pawn ticket. Four hundred handwriting specimens were subsequently checked, with negative results. The case remains unsolved and open.

And deadpan ghastly and bluntforce blunt. Joseph James Reposo, slaughtered for $150 in cash and merchandise. †

JUNE 9

ROOST

211 P.C.—redux.

The Roost rocked. It was a juke joint on Temple and Rampart—a mile west of downtown L.A. A gambler named Les Bruneman was rubbed out there in '37. It was a mob hit. The triggermen drew life terms. Now, it's 16 years later. It's January '53. Two out-of-town punks named Glenn Kingsbury and Robert O'Leary decide to clout the joint. LAPD Vice Officers R. D. Long and E. P. Norman are running tavern checks, catastrophically concurrent.

Combustion!

Long covered the front. Norman covered the back. They let the heist go down. Kingsbury and O'Leary burst out the front door. Long told the papers that he yelled for them to halt— but that wasn't how the game was played in those long-gone/dearly-missed years of yore. Yeah, baby! Officer R. D. Long opened fire and put Kingsbury on the night train to the Big Nowhere!!!!!

Kingsbury stumbled into the Roost and dropped dead, while neighborhood nabobs noshed fried chicken and jacked gin fizzes beside his body. O'Leary sped off in the getaway sled. Officer E. P. Norman radioed in a report. A juvie car chased O'Leary—but the cocksucker *ex*-caped. He was later apprehended in San Francisco.

Dig the corresponding photographs. They portray a heartwarming moment of racial unity in the Jim Crow '50s. Black folks are hobnobbing with Mr. Charlie outside the Roost. Inside, white man Kingsbury is covered by a light-colored cotton shroud that somewhat resembles a Klan sheet. Witnesses are bellied up to the bar. It's an all-male aggregation. Many of the men are smiling. Man, this is a stag nite deluxe!!!!!!!!!! †

JUNE 26

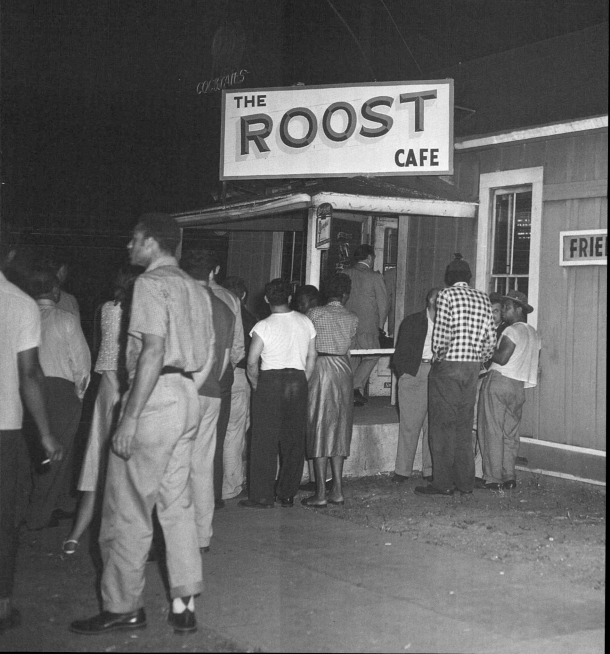

235-300
6-26-53 R.II

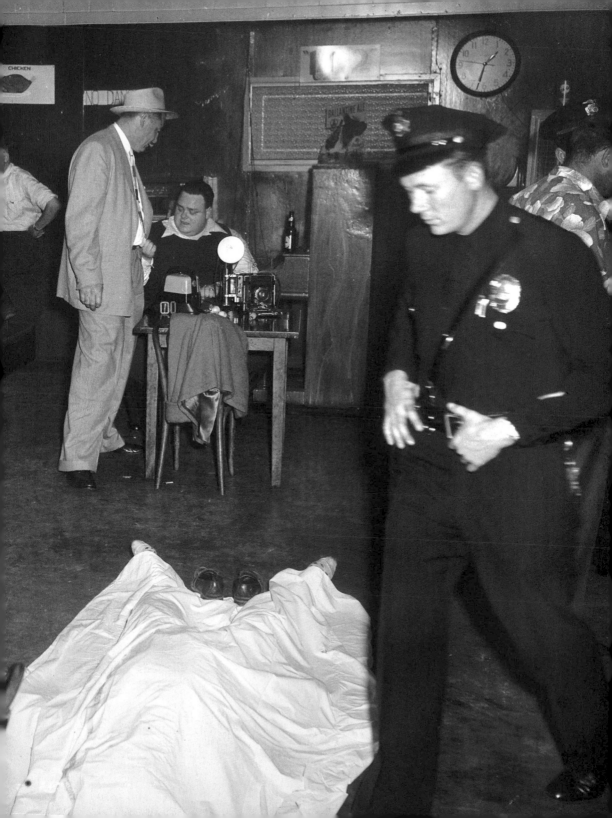

KEYHOLE

211 P.C.—*re*-redux.

We're at the crazy crossroads of Hollywood and Vine. There's a gin mill called the Melody Lane, affixed with a front door shaped like a keyhole. The door opens into a dank dive and despair den for the determined dipso. And, right now, two determined heist men are taking it down.

They're more like heist *punks*, two years out of New York's Elmira Reformatory. We've got Edward Stewart Cogovan and Harold La Verne Riddle, both from Lockport, New York. They were pulling heists and burglaries back east, but they felt cop heat breathing down their scrawny punk necks. They thought L.A. would be Eeeeasy Street. Punks—don't you know that it's Whiskey Bill Parker's town, and there's a bounty on dipshits like you?

Cogovan and Riddle enter the bar. A sharp-eyed Marine notices that

they're armed and buzzes the fuzz. Officers R. L. Newsletter and David Tutor arrive. And, unknown to the punks, two detectives are lurking out on the sidewalk.

We're back inside the Melody Lane. Recognition passes—punks to cops. The punks disarm the cops and march them outside at gunpoint. One of the two lurking detectives is Sergeant Don Grant. Dig it: Fireworks pop!

We know Grant. He responded to the man-in-the-swimsuit suicide later in '53. Remember—infamous "Red Light Bandit" Caryl Chessman accused Grant of beating on him at Hollywood Station. Grant would later watch Chessman suck gas in San Quentin's green room. Presently, Demon Don's trigger finger is *itching*.

Bam! Grant fires. Cogovan gets it in the neck. Riddle is riddled in the chest. Passersby on crowded Holly-*weird* Boulevard scatter and shriek. The punks are disarmed, cuffed and rushed to the jail ward at County General. Kidnapping charges are filed.

The punks survived. Police tele-types revealed that Cogovan shot his father to death in '48 and did that juvie jolt in Elmira. The punks were wanted for the recent punk antics in New York—and had only been in L.A. *four hours* at the time of the shootout.

It's Whiskey Bill Parker's town. Pistol-packing punks, *verboten.* †

NOVEMBER 4

MEXICAN RAT PACK

You thought the "Rat Pack" was a classy clique comprised of Frank Sinatra, Dino Martin, Sammy Davis and Peter Lawford, didn't you? Take another think, *pendejos*. See that cheezy East L.A. niteklub interior? See Ramon "Mundo" Pacheco, dead in the alley behind it? Pacheco's a pachuco, *pendejos*. The *L.A. Examiner* is hot on the trail of Rat Pack Violence.

It's youth gang intrigue. Malevolent Mexican punks are on the prowl. Five punkolas with a grudge against *puto* Pacheco stabbed and beat him to death.

The grief began in the niteklub and spilled out to the alley. There were shitloads of eyeball witnesses who told a coroner's inquest they saw *nada*. District Attorney S. Ernest Roll thought they'd been coerced into silence.

The Pacheco snuff was the apogee of a Rat Pack Crime Wave. Five tuffs bottle-slashed two youths at the edge of Pershing Square. Three pestilent punks jumped a Marine on a downtown street and killed the 56-year-old man who came to his aid. *Woo, woo!* L.A.'s roiling with Rat Pack Fever!

The *Examiner* publishes a Rat Pack Exposé. Dig this nihilistic nomenclature of L.A. '53. The punks are subdivided by age group. "Cherries," "Midgets" and "Chicks" run 15 to 18. If you're over 18, you're a veteran. Gang ranks swell from 20 to 100 members. There's 35 in the "El Hoyo" mob. "Dogtown" boasts 110. There's 35 in "Valley Vampires." There's only 25 in the "Loma Street Gang."

Smell the air? Hear that murky music? It's the scent of testosterone-toasted male madness. It's malevolent and miasmic and lashing latinlike toward *YOU*. The Viscounts and "Harlem Nocturne" wail wickedly at all White Male Americans. Sinatra's Rat Pack is in its impotent infancy. The real rodents are wrapped in rancor and heading *OUR* way. †

DECEMBER 14

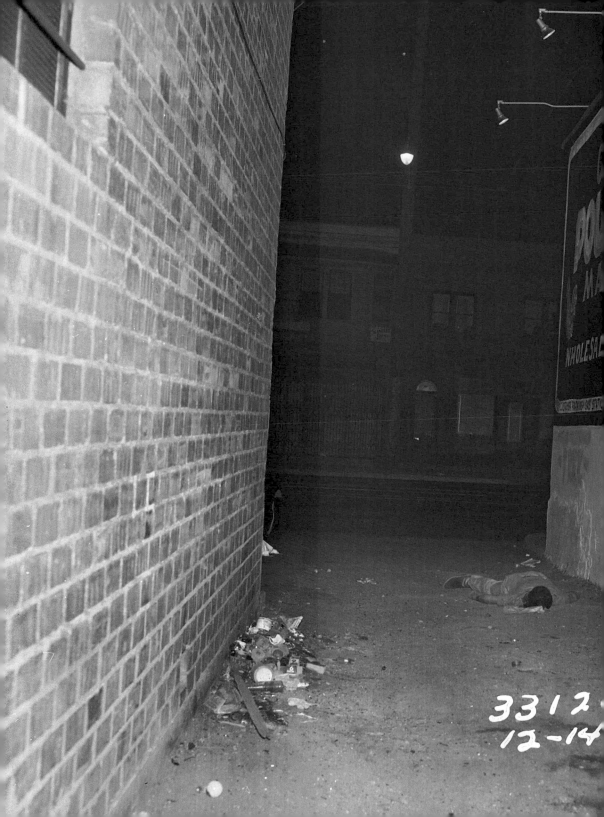

WINO

Jesus Fernandez Munoz. Transient. Wino, stumblebum, derelict, good guy down on his luck. The coroner's register one-sheet is perfunctory. It's an accidental death. Men like Munoz are accident-prone. He was walking on or sleeping on a concrete beam below the Aliso Street Bridge. He might have been blitzed on muscatel, terpin hydrate, or white port and lemon juice. He might have scored some red devils or yellow jackets in East L.A. and added them to the brew. He might have been soberly walking west to downtown L.A. Maybe he was looking for handbill-passing *trabajo* at one of the slave markets on skid row. Maybe he was dreaming of a nice, safe cot at the Midnight Mission. The contents of his pockets went unlisted on the one-sheet. Maybe he possessed the required chump change for a short dog of sweet lucy.

Munoz dropped 50 feet off that bridge. He hit the concrete floor of the L.A. River bed. The L.A. River is a wide runoff sluice. Note the pools of

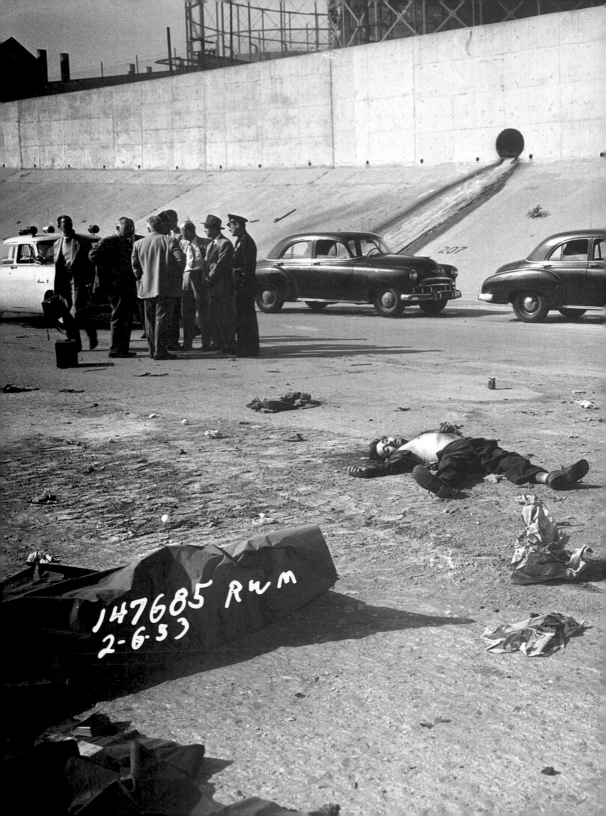

147685 RWM
2-6-53

water from a recent winter rain. Note the dead man's unkempt state. Extrapolate that he *is* a wino or hophead or both. Extrapolate that he *did* die asleep. Extrapolate that he died in the middle of a hop dream. Extrapolate that the dream encompassed the scene of his death.

The L.A. River was a frequent location for horror flicks and films noir. It would go on to provide the climactic backdrop for the '54 giant-ant masterpiece *Them!* Maybe Munoz was a dope fiend with prophetic powers. Maybe he was *seeing* those ants in some draconian dreamscape. They're chasing him. They want to kill him and eat him. They've got giant feelers and giant teeth. Munoz thrashes in his sleep and falls off that beam.

Maybe it wasn't that. Maybe he just poured the pork to a choice *chiquita* back in Boyle Heights. Maybe he bopped from her bed and vowed to start his life over. There's the Aliso Street Bridge. That beam looks like a sweet nesting spot. †

FEBRUARY 6

BROOKS

We're in the garage behind the house at 2927 South Rimpau. It's in the LAPD's University Division. The area is down at the heels, but not sleazoid. The 10 Freeway will bulldoze cribs near this spot 11 years hence. Right now, a grasshopper named Gilford Brown has got this spot pegged as his launching pad for Cloud 9.

Brown, 37, is Hawaiian by birth. He's a movie bit player. He's growing mary-jane on his property. That's a righteous roust in '53. The Narco cop in the pix is the legendary Pierce Brooks. He's the policeman as philosopher-king. He's eyeballing Brown's marijuana plants, growing outside the garage and draped over a mattress box-spring inside. He's got a winsome look on his face. He might be wondering why anyone would fuck their life up with dope. He might be pondering Gilford Brown's psychic disengagement. He might be thinking, "I wish I could transfer to Homicide and slam some *real* desperadoes."

Brooks got that wish. He would go on to apprehend sex creep Harvey Glat-man in '58. Glatman was a bondage-rope freak who offed three women in '57 and '58. He was a camera fiend who photographed his victims bound

and gagged in the moments before he strangled them. Glatman burned in the green room—September '59. Brooks was there when the pellets dropped.

He went on to the Onion Field job—March '63. It's the most celebrated cop-killing in LAPD history. Let's bop forward to a more recent *Then*. Ian Campbell and Karl Hettinger are working a felony car out of Hollywood Division. Gregory Powell and Jimmy Smith are a shitbird oreo team of armed robbers. Combustion and horrible misalliance. Bad moon rising. Powell and Smith kidnap Campbell and Hettinger and drive them to a Kern County onion field. They coldly execute Campbell. Hettinger escapes and later has a mental breakdown. Powell and Smith go through a series of trials and escape the righteous justice of the green room. Pierce Brooks retires from the LAPD as a captain. He creates the VICAP program for catching serial psychos and writes books on policework and penology. Pierce Brooks—LAPD's philosopher-king. He's rousting a reefer man. What is he thinking? †

DECEMBER 1

330707
12-1-53
R.R.

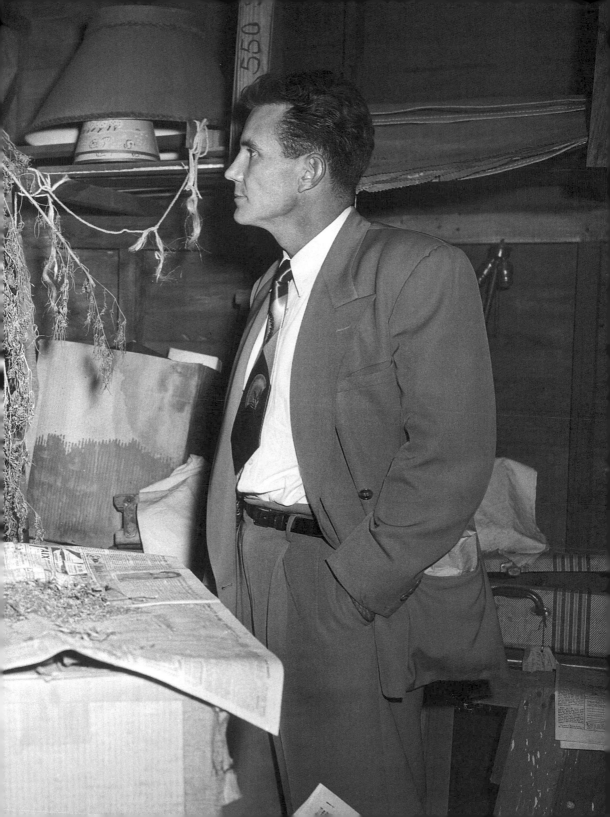

MANUEL

You're looking at a forlorn cat named Manuel Vela, age 38. He's outside a tavern on Erwin Street in Van Nuys. Why is Mr. Vela's face bandaged? Because he got his ass kicked at the tavern earlier that day. Why is Mr. Vela posed with an unloaded gun in his waistband? Because LAPD detectives are staging a reenactment of Mr. Vela's assault-with-a-deadly-weapon beef.

Here's the scoop:

Mr. Vela told the cops that a man named "Joe" pounded him. He was treated for cuts and abrasions at Valley Receiving Hospital and got the big bone for payback. He went home, got his roscoe and returned to the tavern.

He stood outside and fired four shots through the front door.

Thomas Castillo, age 51, was hit three times. One slug almost hit his heart. He caught another shot in the hips and a third shot in the back. *Whew!*—close call—for both Castillo and Vela. Castillo was rushed to County General and survived. Thus, Vela dodged the hot seat at San Quentin.

Joe Martinez, 26, was cut by flying glass. He was treated at Valley Receiving Hospital.

Let's turn an eye to Manuel Vela. He's got that rodent-reptile hybrid look, common to street riffraff. He's hangdog. He's a loser in love. He's probably hung like a cashew.

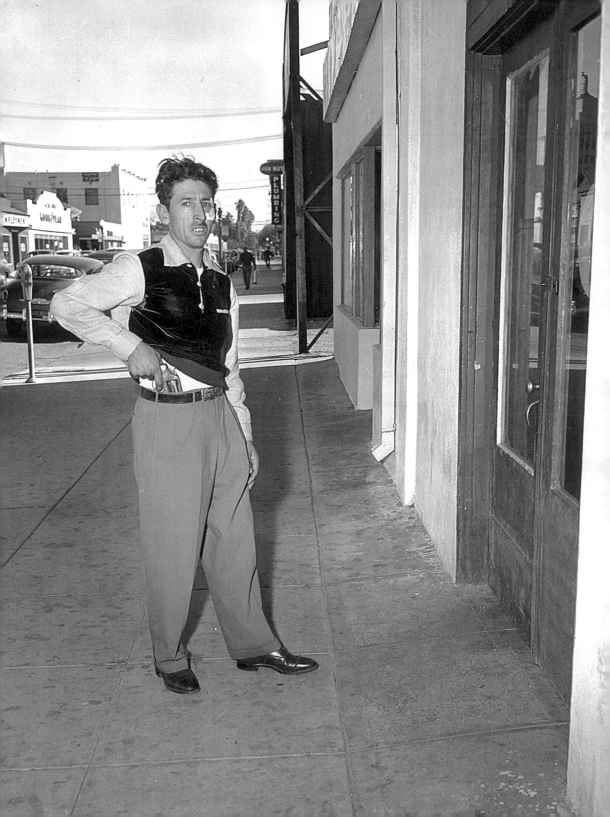

And he looks *relieved*. It ain't no gas chamber bounce. He got his picture in the paper. He'll probably draw a three-spot at Chino and be out in a cool deuce. *He looks relieved*. He's heard that Chino's a sweet deal. He can drink pruno and poke sissies up the brown trail. The food's good at Chino. Dexter Gordon's there on a dope jolt and honks sax in the prison band. The cops have been nice to him. They haven't hit him with a phone book. They keep giving him cigarettes.

Things could be worse. Dig the existential gestalt:

He's made the big gesture. Now *THE MAN* will take care of him and tell him what to do.

Crime is individual moral forfeit on an epidemic scale. †

DECEMBER 12

313 006
12-12-53

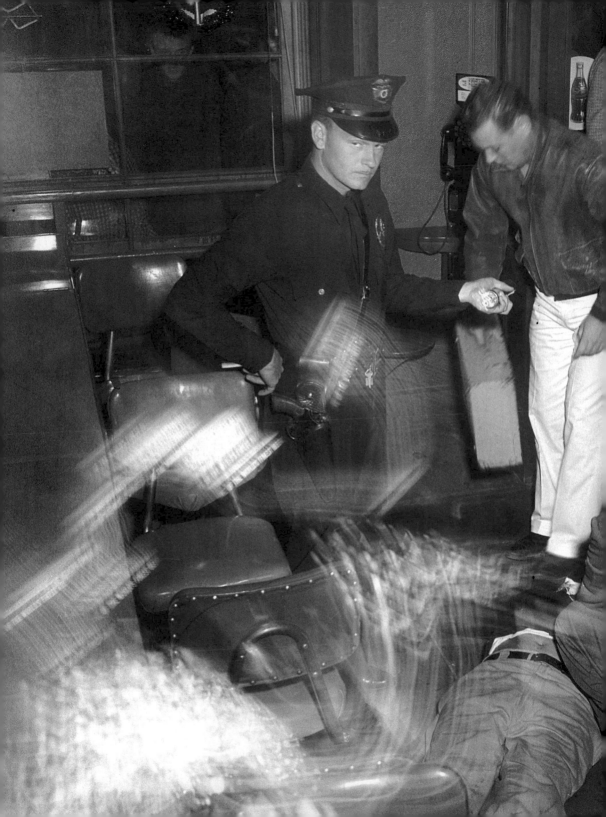

313006

VANDALS

Vandalism.

"Malicious mischief."

Some punks lug huge pieces of concrete over to a large plate-glass window, late at nite. They look into a high-line women's store, of the type common to our *Then*. It's 11/29/53. The front of the store is full of female mannequins. The vandal or vandals hurl concrete blocks through the glass. The placement of the un-pictured blocks suggests *two* vandals. They're sexually driven. They're impotent and enraged. They enter the store and create a tableau.

They topple a mannequin and pull her arms off. Now, she's naked and wearing only high heels. Note the seated mannequin. She's *still* wearing a pricey mink stole. The vandals did not come to steal.

It's probably a *two*-punk caper. It's got to be. It's probably teenagers jacked up on model-airplane glue and early-'50s vintage stroke mags. *Gent, Knave, Cavalier, Nugget*—just enough skin to juice their skin index to *THIS*!!!!!

Little cocksuckers! LAPD Juvie cops should phone-book these punks and pound them for this perv perfidy!

One mannequin has been folded into a fetal position on the floor. Her blonde wig was dropped a few feet away. Her upper body is mink-stole clad—and only her bald head sticks out.

A mannequin is positioned on her side, facing the window. A dark-colored dress has been pushed up over her hips.

Nightfall.

He Walks by Night.

They Drive by Night.

Film noir. 1953. Provocative women in fetishistic attire. Vandals out at *night*. Phone-book them and hold them over-*night*. Have mom and dad make restitution. Write this one off as youthful perv-verve. *Slam* them if they do it again.

But:

It turned out to be a righteous smash-and-grab 459! Desperate B&E men!!! Hopped-up hellions with hot furs to fence!!!

And:

It's unsolved. †

NOVEMBER 29

288A P.C.

It's a week before Christmas '53. Colored lights are up throughout our beloved *Pueblo Grande*. Mock-snow-flocked trees adorn Wilshire Boulevard. Whiskey Bill Parker will dress up as Santa Claus at LAPD's Christmas party for underprivileged kids—and he'll probably be half in the bag. And Hollywood Division's got a hot-prowl/sex creep on the loose!

The crime: 288a P.C.—forced oral copulation. The location: 6724 Hollywood Boulevard.

Yeah, motherfuckers—Holly*weird*. Home of hepcats, hugger-muggers, hopheads, hypes and hermaphrodite he-shes. And, now, we've got this hot-prowl Harry—and he be *baaaaaaaaaaaad* to de bone!

He climbed a fire escape and entered through a narrow bathroom window. He entered in plain view of the bustling Boulevard, all holiday-swarmed. Two detectives are reconstructing the crime. You can tell what they're thinking. This perv-o is scurvy and skinny—it's a tight fit through this window space. One detective is out on a fire escape, gazing westbound. Note the Hollywood Theater marquee on the right. I saw many films noir there as a kid. Dig the elevated perspective. The hot-prowl man climbed a good five stories to get to his prey. The detective stares westbound. He knows the perv has fled. He's staring out at the neon jungle as the neon jungle stares back. He wants to know *Who?* He wants to know *Why?* What corrosive causation coursed before this vile violation, and how does he live with himself?

284 465
12-18-53
P.B.

285465—
12-18-53
P.B.

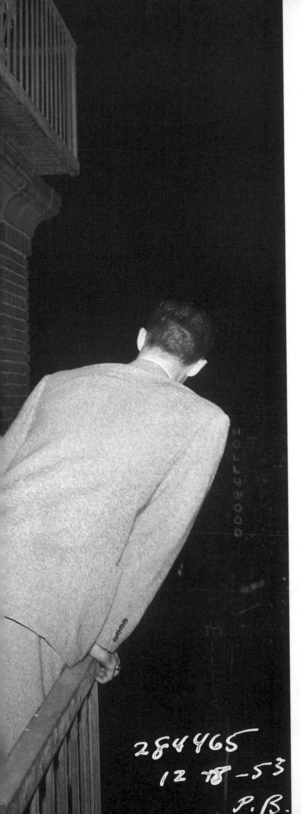

See that sidewalk Christmas tree? It's right in the detective's line of sight. How does such festive expression coexist a heartbeat from horror?

The reconstruction continues. The detectives stand at opposite ends of a long hallway. They're most likely pondering the perv's means of escape. They're standing by the bed where the assault occurred. It's been freshly made. It's 1953. The victim is most likely being attended by a police physician. A properly solicitous policewoman is surely standing by. †

DECEMBER 18

ABORTION

It's 4/28/53. Abortions are euphemized as "illegal operations" in the papers. George R. Davis is a 70-year-old retired osteopath running a clandestine scrape clinic at this home in Highland Park. LAPD's been investigating him for six months. He aroused suspicion late last year. He testified at the trial of a woman accused of possessing illegal surgical equipment. His testimony secured the woman's acquittal.

We're five years shy of David Seville and the Chipmunks' chart-busting hit "Witch Doctor"—but that's who this man is.

There's a full-length mirror in his bedroom. It blocks off a secret operating room with a secret cabinet full of surgical implements. LAPD Detectives Herman Zander, Glen Bates and Danny Galindo pop Davis at his pad/secret clinic, along with a woman identified as his housekeeper. Her *tres* '53 name: Hazel Slocum.

"Housekeepers" commonly appear in '53 police files. They vibe euphemism for "mistress of older, sinister man." This case presents a case for William H. Parker's ordered society of *Then*—decades before the surveillance-camera society of *Now*.

Davis testified at that woman's trial the previous year. Said testimony aroused suspicion. Cops are trained in the art of detecting mendacity. Davis vibed un-kosher on the witness stand. Law-enforcement ears perked. Don't *you* know when someone's shitting you? *I always do.* I'm not a cop. I've never wanted to be one. I live to unravel the mysteries of character and motive. So do cops. Look at the Witch Doctor's orderly home and office. It's a lurid labyrinth. Theodore Roethke wrote, "Is the stair here? / Where's the stair? / 'The stair's right there, / But it goes nowhere.' / And the abyss? the abyss? / 'The abyss you can't miss. / It's right where you are— / A step down the stair.'"

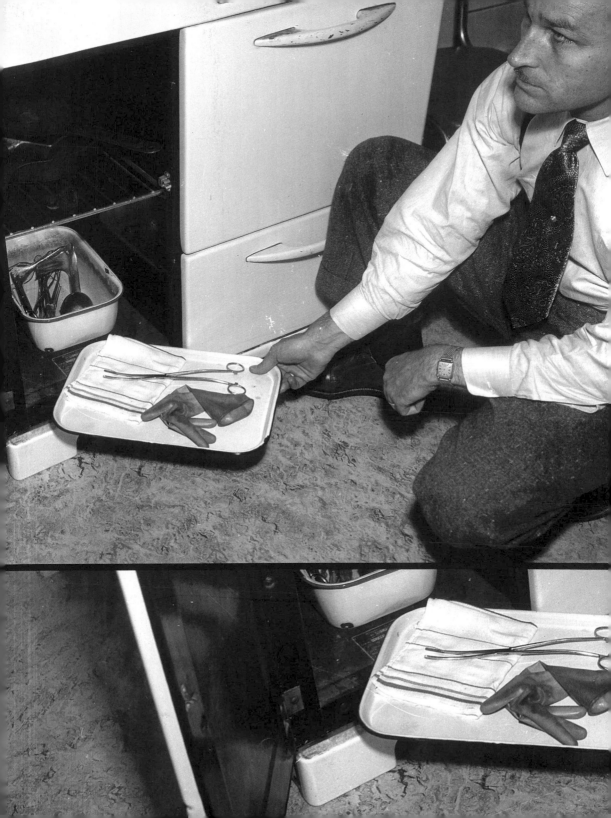

HEPCAT

Let's revisit the kat pictured here. He exemplifies the soundtrack and visual cohort of this book. He's pure bebop and film noir.

He's all about the quick rush of titillation and the abandonment to cheap impulse. William H. "Whiskey Bill" Parker hates this motherfucker—and *not* because he's black. He hates Ricardo Robert White, alias Rickey White, Negro male American—because he lives a slothful life devoted to *SIN*.

He's a hophead, a dope fiend, a junkie, a hype. His daily routine is venally self-serving and meretricious. He's all capitulation. His very existence is a lie. The hordes of hipsters who buy this book will dig him, nonetheless.

Then/Now, Then/Now, Then/Now.

He looks kool. He's thin. He's got a *kool Then, kool Now* pencil mustache. He plays the sax. He spiels jive talk. He's straight out of Chester Himes and Iceberg Slim. He's full of carcinogenic contempt for *THE MAN*. "Subject does not work, but hangs out in pool halls in the Watts area and around 120th and Central, where he is well known."

He's a felonious feline about town. He fulfills our basest urge to morally forfeit. Individual responsibility is a shuck. His kool kat–outlaw look tells us that. Bebop says, *"FUCK THE MAN!"*

Issued Daily except Saturday, Sunday & Holidays by L.A. City Printing Bureau

Daily Police Bulletin

For Circulation Among Police Officers Exclusively

CHIEF'S OFFICE, City Hall (Phone MIchigan 5211 — Connecting All Stations and Depts.) W. H. PARKER, Chief of Police

OFFICIAL PUBLICATION OF POLICE DEPARTMENT, CITY OF LOS ANGELES, CALIFORNIA

Vol. 46 Thursday, March 26, 1953 No. 58

BOARD OF POLICE COMMISSIONERS
HERMAN F. SELVIN, President
DR. J. ALEXANDER SOMERVILLE, Vice-Pres.
EMMETT C. McGAUGHEY
HUGH C. IREY

STOLEN CARS
March 26, 1953

License	Yr. Make Model	Motor
1N47 117	49 Buick Conv	53157235
69 430 M/C	49 Har-Dav M/C	49FL3170
1V20 529	40 Ford CnvCp	185589722
9U2 906	49 Ford Tudor	98BA56111

STOLEN PLATES:
4N8 032 1A74 859 (2)

RECOVERED CARS
March 26, 1953

License	Yr. Make Model	Motor
8B11 108	51 Kaiser Sedan	K2002101
Idaho		
9V1 532	36 Ford Cpe	DR57592
1A74 859	52 Cad Sedan	526206224
(Plts Msg)		

ARREST FOR VIOLATION SECTION 459 P.C. (BURGLARY)

We hold Felony Warrant No. 114430, issued by Judge Louis W. Kaufman, in Div. 4, Municipal Court, charging Violation of Section 459 P.C. (Burglary), for the arrest of **RICARDO ROBERT WHITE**, alias **RICKEY WHITE**. L.A. No. C 254649; LACo. No. B197546; F.B.I. No. 272436B. Bail $2,500.00.

Description: Male, Negro, 22 yrs., 5 ft. 10 in., 135 lbs., black hair, brown eyes, light complexion, slender build. Usually wears small moustache.

Subject is a burglar and petty thief. M.O. is to visit an acquaintance of his, and when acquaintance leaves house, subject leaves with him and then doubles back and burglarizes house by entering through a rear bedroom or bathroom window. Subject does not work, but hangs out in pool halls in the Watts area and around 120th and Central Avenue, where he is well known. Subject is a hype and associates with hypes in the Watts area. Subject plays the saxophone and may be found at jam sessions.

Right Thumb Print
Fingerprint classification:
$$22\ M\ 28\ -\ IOI\ 13$$
$$L\ 8\ -\ OOI\ 13$$

DR 209532.
Hold. We will extradite.
Attention Officers T. J. Nelson and L. E. Valley, 77th Street Detective Division. Kindly notify Chief of Police, Los Angeles, California.

PROPERTY REPORTED STOLEN
March 26, 1953

Adding Machine: 89856, Clary 10 in. wide 18 in. long 8 in. high, gry plastic cover—DR210394

Adding Machine: 3-753616, Burroughs full keyboard manual operated—DR210224

Camera: 13441, Lens 603561, Boluy 35mm mdl B finished in blk lea with brn lea case—DR210163

Drills: (4 in all) 2691230, 2687948, 2688804, 2688984, Black & Decker ¼ in. chuck, 115 volts, 2.7 amps, 3500 rpm, AC-DC, auto—DR210343

Garbage Disposals: Waste King, wht porcelain, packed in blue boxes sz 8x8x16 inches (26 taken in all)—DR208241:
657602 657603 657604 657615 657618 657625
657626 657627 657639 657641 657643 657644
657645 657652 657653 657654 657655 657656
657673 657674 657675 657676 657678 657679
657687 657690

Gun: 18387, Czech Zbrojonka Arthur K. C. make, 25 cal auto bs with clip—DR210414

Gun: 12730-C, Challenger Colt 22 cal auto 6 in. bbl brn plastic handles—DR210146 (Lost)

Radio: 97329, Zenith port black—DR209530

Saw: A240154 Skilsaw mdl 825—DR210309

Saw: 985759 Skilsaw mdl 825—DR210309

Skilsaw: A200799 Elec mdl 77 hand saw 7 in.—DR210392

Skilsaw A670647 Elec mdl 77 hand saw 7 in.—DR210392

Suitcase: 'J.M.K.' Brn lea 2-suiter 30x24x6 inches, lea split handel with checked material, inits in gold letters (stamped on)—DR209666 (Lost)

TV Set: 10907 Muntz 16 inch tbl mdl blond finish—DR209351

TV Set: 14323724 Emerson mdl 694 mahog console full doors 20 inch scrn—DR210283

TV Set: N104806 Philco 14 inch tbl mdl 16, C1, approx size 18x18x24 inches—DR209437

TV Set: 132887 Muntz 17 inch mahog tbl mdl 2-knob control —DR209345

Typewriter: 2A-2232149-11 L. C. Smith-Corona desk mdl, 12 inch carriage—DR210224

Typewriter: 2572158 Royal port tan carrying case—DR209530

Typewriter: 11-6561563 Underwood desk mdl 12 inch carriage pica type—DR210224

Wrench: 'R.L.P.' 'Robert L. Pickel' Ingersoll Rand impact wrench mdl 4U, inits engr on 2 pcs of wrench, name printed on handle, wrench is made to disassemble in 3 parts—DR210255

Wrench: 416075 Chicago Pneumatic air wrench, has long shank sometimes used as a tire iron—DR210281

Wrench: 'Roy Wilson' Ingersoll Rand impact wrench approx 12x4 inches name engr on handle—DR210226

CANCELLATIONS
March 26, 1953

Accordion: 17280 Video, blk, 120 bass in blue imit lea case with brn ginding, has 2 switches—DR140746

Briefcase: 'Newell H. Long' Black lea case with name on tag —DR186313

Checkwriter: 5700584 Paymaster protector—DR202664

Gun: 49737S Colt Woodsman 22 cal auto 6 in. bbl bs with brn basketweave holster—DR140746

Saxophone: 49540 Baritone 'Pan American' orange inside of bell—DR129486

Vacuum Cleaner: X71486H Electrolux mdl LX, blue—DR-205467

Watch: 'To M. F. Whalen from Lipsett Inc, Texas City, Texas' Helbrose 17j mww in stainless steel case with wm expan band, inscr engr on back—DR130141

Watch: 'R.S.' Benrus mww ym sq case wht face nbrs 3, 6, 9, 12 are just gold dots, ym King expan band with inits —DR134424

STOLEN BICYCLES
(Outside the City of Los Angeles—March 23, 1953)

Frame No.	City	Frame No.	City	Frame No.	City
14 006	Pasadena	H409 333	Norwalk	A0752 672	Norwalk
7 092	Culver City	177 347	Pasadena	C23 679	Norwalk
08 103	Pasadena	830 350	Altadena	I33 692	Gardena
K94 105	Lennox	A0849 351	Norwalk	108 710	Norwalk
7E226 105	Burbank	F58 360	Norwalk	164 790	Lennox
F82 114	Burbank	G523 375	Culvr Cty	M239 812	Culvr Cty
A1724 160	Glendale	F208 376	Lennox	B38 825	Lennox
F53 207	Norwalk	G243 394	Firestone	G733 875	Lennox

Film noir tells us that *THE MAN* exists solely to squash the poor and muzzle the artist. "Where there is no God, everything is permissible." Dostoyevsky said that. Ricardo Robert White affirms the horrid pleasures of self-relinquishment. His very being nullifies the fatuous extremes of social critique and extols the wisdom of an unwavering moral compass. What is bebop and film noir abandon to a morally sound person? Three drinks too many and a roll in the hay with someone inappropriate. Ricardo White, *living* bop and noir *Then*: thievery, desiccation, abdication.

"Subject plays the saxophone and may be found at jam sessions."

Get off that pulpit, five-year-old Ellroy! You're the biggest bop and noir hypocrite in the world! There's Rickey White, blatting his sax at Club Zombie. That's you, snapping your fingers and grooving the scene with a spike in your arm! †

MARCH 26

JUMPERS

Jumpers.

6/16/53 and 7/3/53. One Chinese man, one white woman. The man was gravely ill. The woman was "despondent." The latter is the most commonly ascribed cause of suicide. It covers everything from skunk marriage to postpartum depression to loopy loss of love. "Ill health" is right up there. It requires no further explanation. There's no known cure for ailments from cancer to the creeping crud. It hurts to live. You're anxious to get there—however you view the prospect of *"THERE."* These two jobs are pure impulse. The jumpers did not purchase rope, score pills, rig up an elaborate asphyxiation tableau. They simply *leaped.*

Jan Joy was a 40-year-old Chinese man. He checked into the Northern Hotel at 2nd and Clay on Bunker Hill. He left a note behind. It was written in Chinese. The translation: "Been sick long time. No cure. No way out."

Yeah, baby! There's *NO EXIT*!!!!! It's sock-it-to-me Sartre—that freaky frog—all the way!!!!! Jump, baby, jump!

Cut to 7/3/53. Ruth K. Wilson, age 46, jumps from the ninth floor of L.A.'s vividly venerable Biltmore Hotel. Miss Wilson worked in a café a few blocks away. Nix "despondent"—she had the L.A. blues *baaaaaaaaaaaaad.*

Here's the skinny, the gist, the gestating gestalt:

You're like William Bendix in *The Blue Dahlia.* You're hearing that meshugana monkey music in your head. The record's stuck in a groove you can't unhitch. It's urging you toward an

irrevocable act. You're Lee Harvey Oswald, John Wilkes Booth, Sirhan Sirhan and that anarchist fuck who shot President William McKinley. You're hearing that same terrible tune that all assassins hear. Anything beats the stagnant stasis of life on planet earth. Look, world—I'm here. Look, world—I'm gone.

And—you might survive the jump. You're trusting fate or some divine source. Your flight and hard landing just might jolt you into a wild new good-luck life.

Yeah, but not these two. †

JUNE 16 & JULY 3

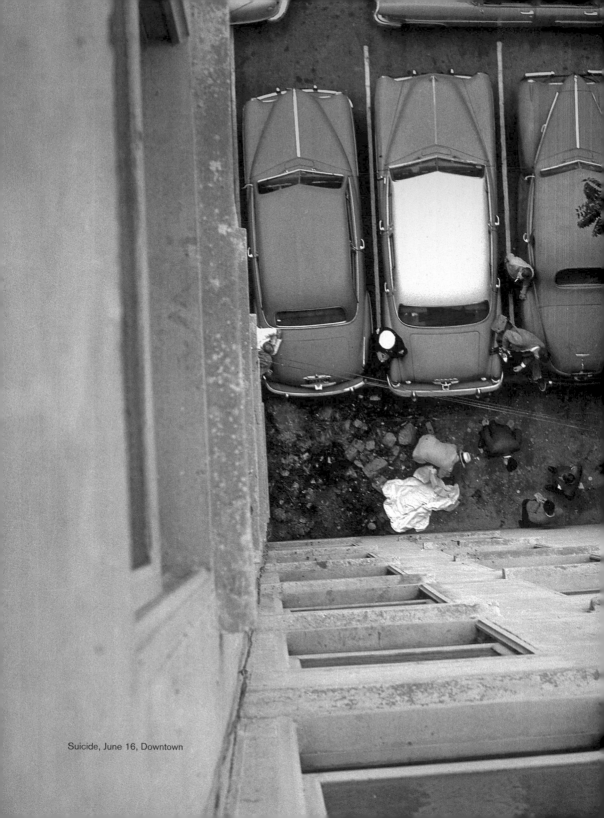

Suicide, June 16, Downtown

GREENBERG

George Delbert Greenberg had had enough. He had a bargain basement .38 caliber Iver Johnson revolver and an innocuous late-model Chevy coupe. He was married. His wife's name was Margaret. They had a pad on Manchester Boulevard, back when that hellbound hood was hunky-dory. There's no known backstory on George Delbert Greenberg. His death did not make the papers. All we have is the coroner's register one-sheet and the pix.

He drove down to the oil fields at 132nd and Figueroa. We're out of darktown and into Gardena. Greenberg traversed a dirt road and found a spot with some privacy. He stood by the driver's-side door of the Chevy and shot himself in the chest. He slumped to the ground, with his head wedged between the door and the car seat.

He was only 28. The death pose suggests supplication. The chest wound suggests a broken heart more than a head wound would suggest the urgent need to extinguish all consciousness. What heartsickness

could be so ghastly as to preempt the idea of all future heart happiness? "Despondency" is listed as the cause of the suicide. It's an insufficient explanation.

Who was this guy?

The "Delbert" doesn't go with the "Greenberg." Was he Jewish? Was he wigged out from World War II or Korea? Did he have too many kids or too much responsibility too soon, and thus fall behind the crush of his lost youth? Was Margaret cheating on him? Was he cheating on Margaret?

Was his girlfriend pregnant and laying down the ultimatum of "her or me"? The Rosenbergs just burned at Sing Sing. Was George Delbert *Greenberg* wigged over *that*?

He'd had enough. Maybe he just choked on garden-variety self-pity. The world wasn't going his way. *Fuck it—I'll show the world I don't need it.* Look at that midshot/close-up. It's a fastidious pose. The gun is pointing outward. It's barely visible—but it's warning *us* not to take shit so hard. †

JUNE 16

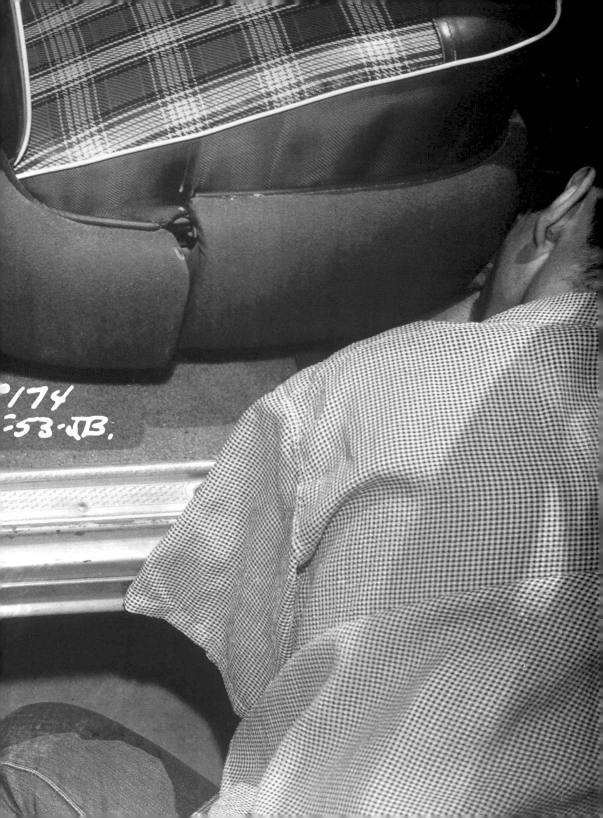

METAPHYSIC

Douglas DeVorss published "metaphysical" books and sold them out of his own downtown bookshop. The façade bore the painted slogan "Books that inspire success." Success at *what*? Was DeVorss a fast-buck, positive-thinking guy? A swoony swami? A rasty Rosicrucian or a zorched-out Zoroastrian? All his office help was felicitously female. Was he a girl-gone guru, running some kind of poontang pyramid scheme in his head? How did he wind up shot dead?

The estranged husband of DeVorss's housekeeper plugged him. It's all madcap middle-aged mischief. DeVorss was 53. The killer—Walter Henry "Jack" Kruse—was 52. The housekeeper—Hazel Mary Kruse—was 45. Mr. Kruse was a former Minneapolis mailman on the skids. Mrs. Kruse told LAPD detectives that he was a "psychopathic case" who had been threatening to kill her and her children, and that she had been afraid of him throughout the 27 years of their marriage. *Woo, woo*—this job has marital *mishigas* stamped all over it! DeVorss was in marital mourning. His much-younger wife died during childbirth on 6/1/53. He met Mrs. Kruse six weeks before his own death. She told him that she was deathly afraid of her husband and leaned on his shoulder. He installed her as the "Housekeeper" at his millionaire's metaphysical mansion in Pasadena. Walter Henry "Jack" Kruse got wind of it. Shit turned south from there. *Bam!*—there's Doug DeVorss, dead.

The victim had a sweet deal going. His Pasadena pad cost him 50 G's, back when that was *gooooooood* gelt. He had his front-office harem. A gardener at the DeVorss crib said he only saw Mr. DeVorss on one occasion. It was a few weeks before the shooting. "He seemed to be sobbing, crying."

Why? †

SEPTEMBER 24

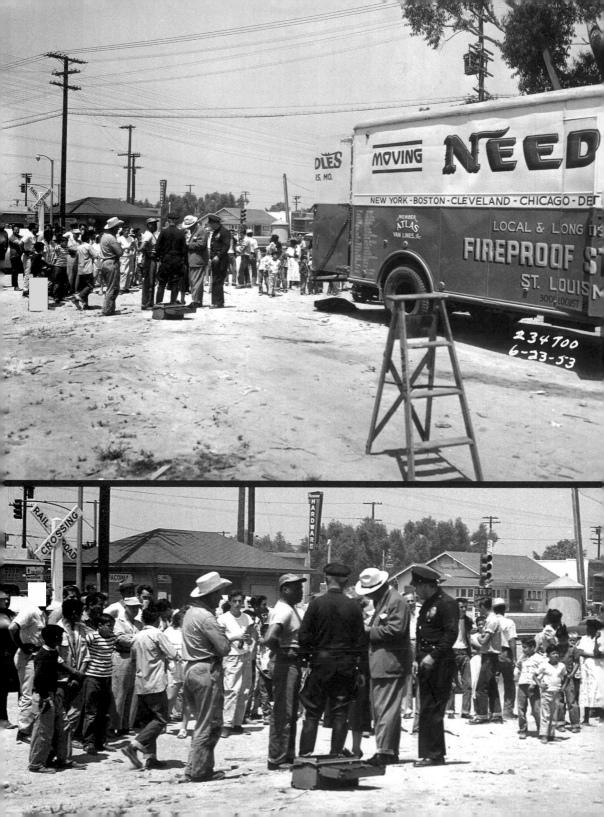

PACOIMA

We're out in the Valley hotbox hellhole hamlet of Pacoima. Ritchie Valens hailed from there. He was a pachuco pinup boy and three-hit wonder out of '58 and '59. "La Bamba" and "Donna," remember? Gooey prom-nite tunes. I used to peep a girl named Donna Weiss in junior high. She was fine as wine, *ese*!!!!! "Donna" always brings *Donna* back to me. Rockin' Ritchie died in an overcelebrated plane crash. He was *Then* and is *Now* Pacoima's favorite son.

That was later, *ese*. This is *Now*—back when *Now* is 6/23/53.

There's a big, abandoned trailer. There's a bludgeoned-dead dead man inside. He's Herman Hodges, age 35. LAPD detectives have reconstructed his last cross-country drive.

He left St. Louis on 5/22/53. He was accompanied by a Negro man—35, 5′ 8″ to 5′ 10″, 135 lbs, slender build, medium dark, long protruding nose, dressed in dark blue denim jacket, dark trousers, dark-colored felt hat with the brim cut off. It is believed that the male Negro killed Hodges and drove off in the truck part of the truck-trailer after their L.A. arrival on 6/14/53. The truck was found abandoned in Bakersfield, 7/3/53. No physical evidence was found in either the truck or the trailer. The case remained unsolved as of 3/14/54.

It's a bustling third-world crime scene. There's a nine-days-dead man in the trailer. Local Pacoimaites are huddling and digging on the white man's show. LAPD Lieutenant E. W. Smith theorizes this:

The two men made their final delivery, drove to the vacant lot and parked the truck and trailer. They crawled into the trailer and went to sleep. The suspect bided his time and killed Hodges then.

Who is the male Negro with the long protruding nose? †

JUNE 23

WILLIE

One more time, kats—the walls were closing in on him.

Willie B. Miller lived with his wife, Clara Mae, in Watts. He started drinking and slashed Clara Mae's throat with a cleaver. The three Miller kids remained unharmed in the pad.

Willie called his sister-in-law and told her he whacked Clara Mae. The sister-in-law called *her* sister, Mrs. Willie R. Womack, and spread the news. Mrs. Womack drove to Clara Mae's house. Willie Miller snapped rifle shots at her from the porch. A neighbor called LAPD. The Battle of Watts was on!

Officers L. L. Lipe and William Lesner sped over, Code 3. Willie fired a shot, smashed the windshield and grazed Officer Lipe in the arm. The officers hopped from their black-and-white and laid down return fire.

Reinforcements arrived. A dozen prowl cars and police motorcycles hit the location. Willie's pad was surrounded. There's *NO EXIT!!!!!*

Officers called out for Willie to surrender. Willie ducked back inside his crackerbox crib and sent a rifle shot *wiiiiiiild*.

The cops lobbed two tear-gas bombs through a front window. The pad filled with noxious fumes. Willie staggered outside with his rifle. "Drop it, Willie." "Drop it, Willie"—the cops warbled that warning. Willie's looking dat *baaaaaaaaad* grim reaper straight in the snout. An armored arsenal is pointed at him, with a big bull's-eye pinned to his chest.

Then Willie "drops it." Then Willie puts his hands up.

Why'd you do it, Willie? Give us the straight shit on that.

Willie told his sister-in-law: "Clara made me shoot her." That was a lie. Willie slashed her with a cleaver.

It was just one of those days. The walls were closing in. Implosion, explosion. Boiling point. The "I've-had-enough syndrome," redux. †

MAY 11

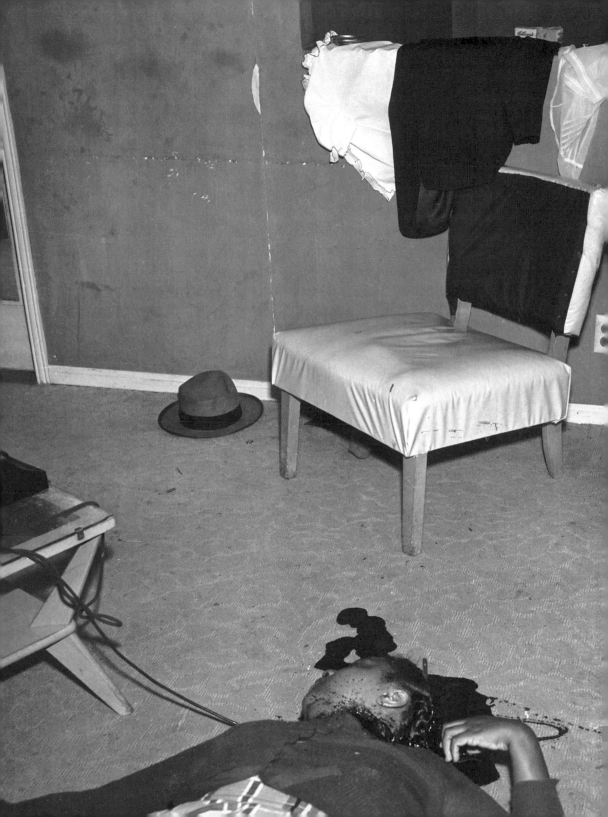

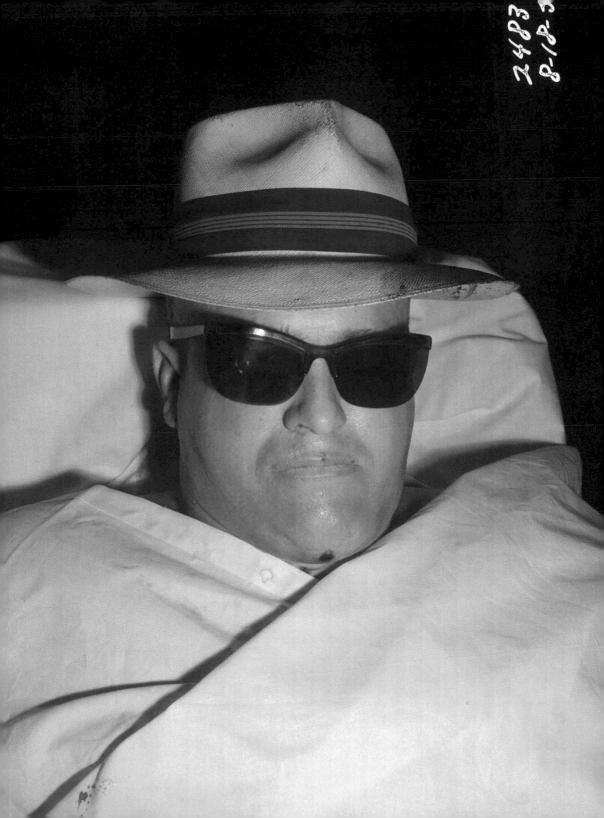

PHILIP SEYMOUR HOFFMAN

This photograph brings to mind the recently OD'd actor Philip Seymour Hoffman in his hambone portrayal of writer Truman Capote. It's not the late Mr. Hoffman or the late Mr. Capote. It's a dead bank robber named Louis W. Hammert.

Mr. Hammert, 34, did an eight-year fed jolt for bank robbery and was paroled from the McNeil Island pen on 5/9/52. His pre-jolt heist turf was Washington and Oregon. He's in L.A. now. It's Whiskey Bill Parker's town, but Louis W. Hammert has chosen to ignore that. It's August '53. He rolls the dice and comes up double-zero. He clouts a bank on 6th and Spring in downtown L.A. The eagle-eyed chief guard, Herman Miller, blasts his pudgy ass. Hammert expires in the jail ward at County General several days later.

Hoffman and Capote died too young. Hammert died right on cue. Morgue jockeys, medical examiners and homicide cops are irrepressible cut-ups. Someone decked Hammert out in shades and a straw fedora. It's *howl*arious shit, all the way.

This foto caption is devotedly dedicated to my main-man mentor, Joseph Wambaugh. Jolting Joe served on the LAPD from '60 to '74 and went on to create the modern police novel as we now know it. I was a minor miscreant about town when I read Joe's early books: *The New Centurions*, *The Blue Knight*, *The Onion Field* and *The Choirboys*. They were *my* L.A., vividly reconceived and retold from a sternly authoritarian and provocatively funny perspective. Those books rendered me ashamed and ultimately repentant for my lawless actions and doubled me over with a ceaseless barrage of street humor. Sex yuks, race-derived guffaws. Dope-fiend and diseased-drag-queen hilarity. Profoundly profane, and always striking my own chord of theocratic Tory rectitude melded with street jive. Many cops think and talk like I do. No other writers do. What *is* this strain of humor, distilled to its essence? It's the male world in extremis, gone hilariously mad. †

AUGUST 18

BABY ELLROY

Happy Birthday, Dipshit Ellroy—you just hit the Big 0-5!!!!!

It's 3/4/53. I'm celebrating with Sergeant John O'Grady, Lenny Bruce, Ava Gardner, Charlie "Bird" Parker and John Coltrane at the Club Zombie. We're bennie-buzzed and about to head out to the Admiral Theater for a midnite screening of the film noir *Split Second*. It's a subgenre of one: "A-bomb noir." Hard-hearted heist men herd hostages to a hideout in the Nevada desert. They *think* they're safe—but the Army's about to test a big A-bomb right there!!!!!

The flick's a gas. It co-stars my main *mujer*—alluring Alexis Smith! I'm grokking it—but O'Grady gets called away to a suicide at the Highland Park Station jail.

What a waste of time! Cops call callouts like this "trash runs." The decedent is a despondent dude named Manny the Molester. He hung himself with his belt in his jail cell. Men will go to any and all lengths to be *HUNG*.

Manuel S. Pazo, age 26. A lizardlike Lincoln Heights loser. LAPD popped him at Albion Street and Avenue 17.

Bystanders eyeballed him mauling a 15-year-old girl. She told LAPD that Manny the Molester tried to get her to smoke a reefer. She refused. Manny beat her and tore her clothing.

Easy come, easy go. Manny's dead. Note his retroactive resemblance to President Barack Obama.

O'Grady splits Highland Park Station and re-rendezvous with the gang at Dave's Blue Room on the surging Sunset Strip. We crash crêpe suzettes and dig into Dom Pérignon '39. Alexis Smith drops by the table. She slips me her phone number on the Q.T. I tell her I'll call her from the secret phone in my crib at my parents' pad at West Hollyweird. Her voice goes low as she calls me "baby." I say, "Don't call me that—you're touching a nerve."

The gang laffs. O'Grady regales us with a tale of Manny the Molester's suicide. It's the hard-charging L.A. of 1953. It's Whiskey Bill Parker's town—and *we* live in it. †

MARCH 4

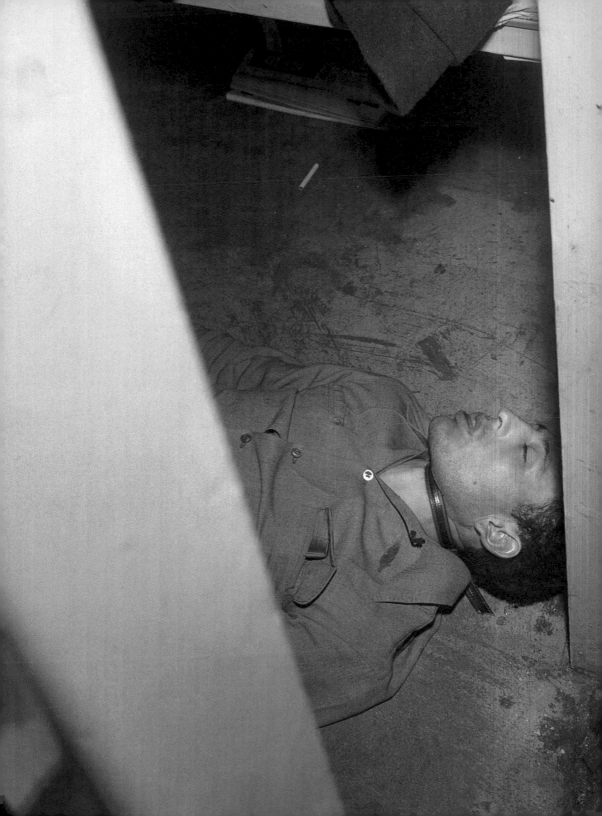

204284
3-4-53-R.M.

LOS VATOS

Happy Halloween, muchachos! God-forsaken goblins are out on the prowl. Yeah, it's another wave of machismo-mangled Mexican murder. One Mex marauder is *muerto*. Mayhem boils in Boyle Heights.

We're at 3072 Oregon Street. Ray Barreala and his sister Gloria are hosting a barrio bash for White Fence gang members. The clock hits 11 p.m. Six youths from a rival gang show up, with rifles. This is a treacherous trick-or-treat. One youth points his piece at Joe Louis Vasquez, age 19. Vasquez falls, dead. The youths ex-cape in a lite-colored '50 Ford.

It's another outbreak of Rat Pack Violence. And it's *not* Mickey Mouse misogynists Frank Sinatra, Dino Martin, Sambo Davis and Peter Lawford beating up their wives and girlfriends.

Six suspects get popped for the Vasquez snuff. It's another futile and fucked-up fatality in the ongoing L.A. Rat Pack Wars. These repugnant rodents roam East L.A and lope through Lincoln Heights. They've chewn up Chavez Ravine. They've demonized Dogtown in Glassell Park. They're dick-deep in narcotics peddling, armed robbery, burglary, bookmaking, gambling and insidious incursions into rival-gang turf. Get this: There's a gang called the "Valley Cutdowns." They're a "baby" group with members ranging from ages 9 to 17.

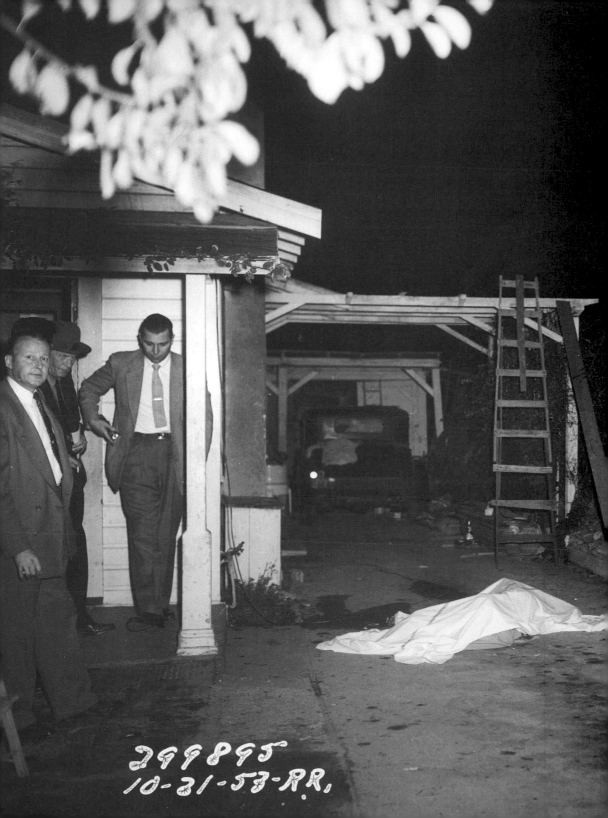

299895
10-31-57-RR.

They're pridefully pre-feminist, with four or five girl members. The Lower Alpine gang has been in several shooting scrapes with members of the Macy Street gang. The Lower Alpines are well known to be bad *borrachos*, with a pervy penchant for drunkenness. The West Temple gang is admirably inclusive, and includes Anglo and Negro members, as well as those of Mexican descent. The Rose Hill gang supplies maryjane and horse to youths in Pasadena, Alhambra, San Gabriel and Boyle Heights.

 "Whirl is king."

 Some ancient Greek said that. Socrates, Aristotle—one of those cats. It's all Greek to me. Hey, *Socrates*! Wasn't he a member of the Parthenon Patriarchs gang? †

OCTOBER 31

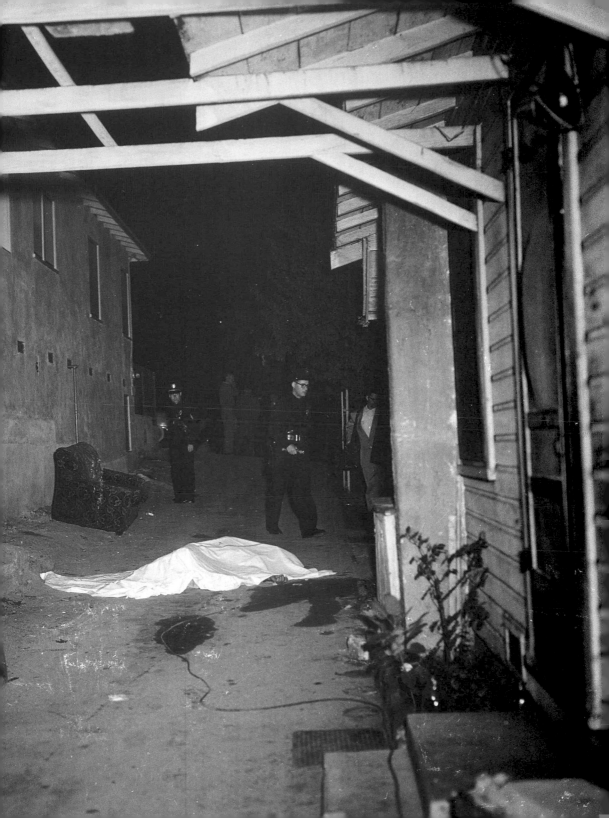

D-201 547
2-22-53

HANDS

See those hands? They're the hands of a killer. He killed a friend of his. They'd been friends for five years. The beef occurred on 2/22/53. It's a spur-of-the-moment drunk beef. It's another instance of Demon Don DeLillo's "neon epic of Saturday night." Our players are Clarence E. Vickery, Jr., age 33. He's an aircraft worker. He's the killer. The dead guy is Paul M. Kenney, age 42. He's a grocer. Both men live in the dog-dick San Fernando Valley town of Sun Valley.

The tiff goes down at a gas station on Foothill Boulevard. The men had been barhopping and were shitfaced drunk. Vickery told LAPD that Kenney attacked him. "I tried to avoid a fight," the admitted killer said. "Kenney came at me with his hands up and hit me in the mouth."

Woooooooo!—it's on! Vickery said, "I knocked him down and his head hit the pavement. I picked him up and hit him again, and then I kicked him several times in the face and head."

PLEASE DRIVE
TO FORWARD
PUMPS
THANK YOU

CHEVRON
SUPREME
GASOLINE

CONTAINS
LEAD

CHEVRON

DR 201 547
2-22-53

It was enough. Vickery *sensed* that it was enough. He hailed a motorist and told him to call an ambulance. He waited for LAPD to show up. Paul M. Kenney was later pronounced DOA at Valley Receiving Hospital.

The issue of ethnic identity attended this brawl. LAPD Officer T. J. Tighe arrived at the scene and felt for Kenney's pulse. There was none. Officer Tighe said, "This man is dead."

Vickery said, "Good. I'm glad I killed him. I had to show him that the goddamned Dutch will never be as good as a Scotchman."

See those hands? They're the hands of a killer. See Clarence E. Vickery, Jr.? He's a pudgy putz proudly preening for his 10 seconds in the *slime*light. He'll draw a two-spot at Chino. Big-time armed robbers processing out after a dime jolt in Folsom and Big Q will surgically survey his punk ass and call him "Killer." Check out Clarence E. Vickery, Jr. as he stands in the *Now* of '53 *Then*. He'll wake up in the Valley Division Jail the next morning. He'll have sobered up. He'll think, "Shit. I killed my old pal Paul." †

FEBRUARY 22

DR-201 547
2-22-53

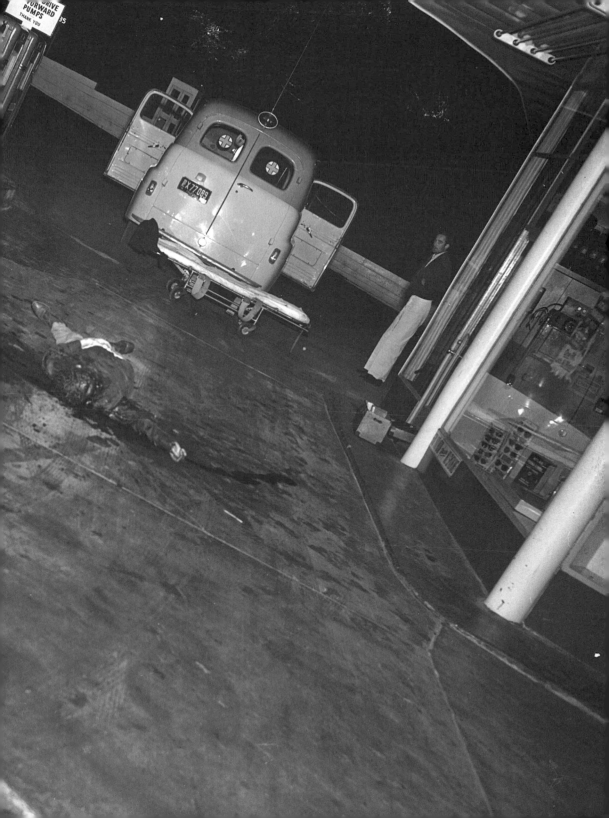

FREAK

Dig this photo from a '53 obscenity case. It's copycat, all the way. We're back in Holly*weird*. We've had the Melody Lane tavern shootout, that forced oral copulation deal, and now *this* slide through the slime.

The pad is on Grace Avenue, a hilly hive sandwiched between Cahuenga and Wilcox. The crime is a perved-out B&E, strongly inspired by a '40s Chi-Town case.

Billy Heirens, the teenage burglar/rape-o/killer from the Windy City. He broke, he entered, he assaulted, he slayed. He lipstick-wrote "Stop me before I kill more" on a mirror in one of his victim's homes. He was apprehended a short time later. He was too young to fry in the chair. He drew a life jolt in Joliet and squawked his innocence. Bad Billy, the lachrymose lunatic. Always making with that baleful babble of boo-hoo.

Cowardly, punk motherfucker. They should have fried his underaged untermensch ass!!!!!!!!!!!!!!!!!!!

And he inspired *this* twisted shit:

The man B&E'd. He didn't steal, he didn't molest—it wasn't a hot prowl with a sleeping woman on the premises. He reconnoitered, he redecorated, he inscribed, he pleaded, he beseeched, he boasted, he offered, he adorned.

And—the fucker laid on some lewd lunatic love.

There's no file on this caper. This leads me to fan fantasy flames. *Oooooooooooh*, he's got it *baaaaaad* for the lady of the house. He snuck in and purloined panties on priapically previous break-ins. He's followed her home from Hal's Nest and Don the Beachcomber's. He digs her swervy sway as she treks trippingly up Grace Avenue. He sticks to the shadows and *lurks*. The woman's nylon stockings go *scree-scree*. It madly metastasizes into the beat of torrid tom-toms in his head.

He's a passive putz. He's never been laid. He spends all his gelt on girlie mags and burlesque shows downtown. He's hung like a light switch. He lives in a sleazoid residential hotel. He wants *seeeeexxxxxx* and *looooooooove*—but he crossed the line into punk pathology a dog's age back. He's a creepy criminal now. He'll crazily cross the line one day. It's Whiskey Bill Parker's town. LAPD will bag his punk ass. †

JUNE 25

EAGLE

The Lone Eagle.

Check this motor officer *out*. He's perched on the newly completed Hollywood Freeway, looking east. We've got Silver Lake and the Hollywood Hills off to the north. The Eagle is wearing one of those heavy-ass shearling bomber jackets that nobody looks good in *Now*—because they were only meant to be worn in workday-professional context *Then*. I've owned a half dozen of them—and I always looked like a buffoon. Why? Because I'm not a motorcycle cop and I've never piloted a B-52 on a bombing run over Germany.

The Lone Eagle's something else.

He's proud. He's wary. He's a devotee of the strange and bizarre, *and* he's an ardent proponent of the stern rule of law. It's Whiskey Bill Parker's town. He's the henchcat to L.A.'s *Il Gattopardo*. Parker's got him on a long leash. He's staring out in muted wonder at this great innovation—*THE FREEWAY*.

He's gassing on the freeway, L.A., America and the world—exactly as it is in *Then's Now*. He doesn't want to see this magical concrete ribbon get fucked up with crunched metal, shattered glass and spilled blood. He's looking for infractions that might contribute to sloth and chaos. He's poised to righteously interdict and suppress. †

BEEFCAKE

It *is* a great city *Now*. It *was* a great city in the *Then* this photo was snapped in. I've dumped on L.A. *Now* in the course of writing the text for this book—but the truth is I can't live anywhere else. L.A.: Come on vacation, go home on probation. My probationary period is long over. L.A.: It's where I go when women divorce me. L.A.: I have to be here to scrounge script deals and movie moolah. L.A.: Most of the people I love are here. L.A.: The town that made me, and that I must return to, again and again.

L.A.'s a movie town. Jack Kerouac does a riff on L.A. cops in *On the Road*. He castigates their hard-hearted enforcement methods and ponders the he-man handsomeness of the policemen of the era. Command Presence was an essential William H. Parker construction. Command Presence diverted, deflected and interdicted crime all by itself. Parker wanted

presentable young men to stand out front in his good-looking town in the business of good looks. Note the recruiting poster on display at the '53 L.A. County Fair. *Dragnet* is now on TV. The unhandsome Jack Webb and Ben Alexander impart a Joe Everyman as Sergeant Joe Friday and poky Frank Everyman as Officer Frank Smith vibe. A caricatured Hal Handsome peers from the poster. He vibes Übermensch in blue. He *has* to look good—it's Whiskey Bill Parker's town, and Whiskey Bill wants his boys perfectly etched.

Imagery.

A tall man in the foreground is approaching the poster, with a big smile. The fucker looks like Cary Grant. He's probably hot to enlist.

Kerouac disdained L.A. cops. They weren't chubby, prone to chump-change corruption and lacked simple human heart. Yes, they were by and large fit. Yes, almost none of them sought handouts. No, their hearts weren't up for grabs in a programmatically permissive way.

L.A.'s like America. It was that way *Then* and *Now*. Everybody dumps on us. Everybody wants to come here, nonetheless. †

OTASH

Fred Otash served on LAPD from '45 to '55. Whiskey Bill Parker harassed him out. He instinctively and properly distrusted Freddy O. He knew that Freddy O. was cunningly rogue. He had no specific dirt to squeeze him with. He shuffled him from division to division, willy-nilly. Freddy took the cue and split. He became a private eye and went to work for *Confidential* magazine. He employed illegal surveillance methods and got the goods on celebrity pervs. Freddy was strictly shakedown. Freddy knew how to carve a buck.

Freddy lost his P.I.'s license in a horse-doping snafu. He became a freelance mob lapdog then. Fetch, Freddy, fetch!!!!! Freddy worked for all the godless goombahs. Jack Kennedy was playing bring the brisket with Marilyn Monroe. Sam G., Mr. Chi-Town, was considering a squeeze on the Prez. Freddy hot-wired Peter Lawford's beachfront fuck pad and got audiotape on Jack in the sack. Freddy told me that Jack was a two-minute man. I live for this kind of insider shit—and don't tell me you don't!!!!!

I knew Freddy in his declining years and have deployed him as a character in three of my novels. I dug him—but didn't respect him. He lacked my humility and sterling strength of character. He tried to crash my own shakedown gig when I was a five-year-old L.A. rackets overlord in 1953. Freddy Otash, ex-LAPD: 1922–1992. Thanks for being there *Then*. †

No. ..

Name ..

Order ..

Remarks ..

Retouched ..

Order Finished ...

Reorder ...

Reorder ...

ELMER

Everything is connected. We are all as one, connected in the *spiritus mundi* and the gravely groovy big chain of life. Elmer V. Jackson started at the LAPD in '37. This ID pic portrays him as a carrot-topped youth. Elmer J. worked Administrative Vice in the late '40s and was a key player in the Brenda Allen vice scandal of '48–'49. Said scandal toppled Chief C. B. Horrall and ultimately facilitated the reforming regime of the illustrious William H. Parker. Elmer J.'s a supporting player in my most recent novel, *Perfidia*. John Gregory Dunne used him as the basis for Lieutenant Tom Spellacy in his splendid 1977 novel, *True Confessions*. Jackson was Brenda A.'s lover. Ambiguous shit went down with her and sparked the entire scandal. The late Mr. Dunne has Brenda *Samuels* giving Spellacy a head job in the front seat of his car.

An ex-con tries to rob them with a tommy gun. Spellacy drills the guy while Brenda's gobbling him, tonsil-deep. *I* portray Brenda Allen and Elmer Jackson's relationship more delicately.

Sergeant Elmer Jackson worked Wilshire Detectives in '58. He handled the missing-persons inquiry on one Ruth Rita Mercado. Poor Ruth Rita was snuffed by sex creep Harvey Glatman. Harvey Glatman was briefly a suspect in my mother's murder case. Pierce Brooks, LAPD's philosopher-king, popped Horror Harv. See, it's all connected!

Elmer the J was on the job in our 1953 *Then*. He was a vibrant 38 years old, with Brenda Allen years behind him. He managed to retain his LAPD tenure after the scandal blew over. Bill Parker surely disapproved of him. There's surely a story here. †

L.A. POLICE DEPT.

1 7 8 2

CHRISTMAS

Feliz Navidad!

We're back on Holly*weird* Boulevard and southward on the Miracle Mile. The sidewalk trees are out. Folks are well-groomed. There's no crime as a continuing circumstance anywhere to be seen. It's Whiskey Bill Parker's town, holiday-dressed.

The Admiral Theater's running a boss double bill. Gregory Peck toplines an oater. Joe Cotten stars in a crime lox. The Melody Lane is just to the right. That big botched heist shootout is 16 days in the past. Local barflies are still schmoozing it up. The punk-pipsqueaks who ate Sergeant Don Grant's hot lead are off the critical list. Note the kool kars in style transition. Humpbacked is out, rocket ship is in.

It's good to be an American, right? It's good to live in L.A. It doesn't matter what's playing. Tuck a short dog of Old Crow in your pocket and nip along with the movies. Head over to Ma Gordon's Deli, post-flix. It's the "Home of the Hebrew Hero"—tasty and deadly shit. There's no hipster riffraff on their computers at Ma's. There's just square folks and lonely Joes with big dreams, like you.

You can nosh and stroll down south to the La Brea Tar Pits. You can ponder why no women want you. You can eyeball the statues of woolly mammoths and saber-toothed tigers, and reflect on eternity. What will the gleaming Miracle Mile look like in, say, 60 years? It's the sort of shit you teethe on with a double feature, a pint of hooch and a big pastrami sandwich kicking around in you—

Then. †

ANTHEM

They're playing our song.

It's either the National Anthem or "God Bless America." The LAPD Band is in full roar. All of the cops are saluting. Many of the civilians have doffed their hats or have placed their hands on their hearts. It's the ground-breaking ceremony for the new Police Administration Building at 1st and Los Angeles Streets. The celebrated architect Welton Becket designed the space-age modernist structure. It will replace City Hall as the LAPD's administrative hub and will ultimately and posthumously be named "Parker Center."

But, fuckers—why mince words or mince at *all*? City Hall is City Hall.

It's the most magnificent building of L.A. *Then* and remains the signature building of L.A. *Now*. It's the most striking and immediately identifiable seat of municipal government in America today. And, it's the defiantly donkey-dicked declaration of L.A. and Bill Parker's LAPD as the epic epicenter and invigorated enforcement arm of film noir.

Yeah, kats—it's '53. The LAPD Detective Bureau's running round-the-clock out of City Hall. What would film noir be without City Hall as an L.A. landmark, L.A. identifier and the fabulously phallic symbol of the fucked-up finger of fate?

Criss Cross, '49. Robert Siodmak

directs Burt Lancaster, Yvonne De Carlo and Dan Duryea. Dig it: City Hall's top-loaded at the start of the flick. There's an armored-car heist and boocoo sex and death coming up. And what's the gist?

YOU'RE FUCKED, Daddy-O—and you're loving it!!!!!

He Walked by Night, '48. There's a jejune Jack Webb in this one. A fiend cop-killer's on the loose. LAPD's massively mobilizing to bag him. The Detective Bureau's jam-packed with lurid lowlifes snared in raucous roundups that violate their candy-ass civil rights! City Hall looks good like a motherfucker! Those fucking marble halls gleam!

D.O.A., '50. Edmond O'Brien's been dosed with a slow-acting poison and snags his own killer! Man, this cat is cooked! There's City Hall in the beginning. Soon-to-be dead man O'Brien walks down those long marble halls to tell LAPD Homicide *all*.

"Mark him dead on arrival" are the last words of the film. The same epitaph could be applied to L.A. *Now!!!!!*

They're playing our song.

You can't go home again.

At least we've got History.

At least we've got imagination and memory.

At least we've got Art. †

Groundbreaking for the police administration building (later renamed Parker Center)

CHESSMAN

It's a grisly artifact, to be sure. And Caryl Chessman, the "Red Light Bandit," would not burn *today*—because he did not commit murder. "Chess" fried under the aegis of the "Little Lindbergh Law," put into effect after the 1933 kidnap/death of Charles Lindbergh, Jr. The law held that kidnapping with grievous bodily harm carried the possible imposition of the death penalty. Caryl Chessman prowled lovers' lanes in the Hollywood Hills. He drove a dark car with red cellophane affixed to a side spotlight. He impersonated a policeman and abducted women from the automobiles where they sat spooning with their boyfriends. He walked them at gunpoint to his faux unmarked cop car and coerced sexual acts. He returned them to their automobiles and drove off into the night. It was '47 into '48. A woman molested was a woman unjustly and permanently stigmatized. Caryl Chessman branded his own scarlet letter into the innocent flesh of a score of young victims.

He battled the green room for a full dozen years. The green room won in the end. The document pictured foretells Chessman's 2/19/60 date with lethal gas. Chess won that one. The pellets dropped him two and a half months later.

The great chain of life—and death.

Joseph Wambaugh entered the LAPD Academy that day. It was seven years after Sergeant Don Grant's tavern shootout at Hollywood and Vine and the man-in-the-swimsuit caper.

Chess sits down in the hot seat. Grant's watching from the other side of the glass. The eggs drop in the acid. Invisible gas fills the green room.

Chessman dies gasping for breath. It's a horrible moment that would not have occurred today. It was *Then*. The death penalty is more sparingly and judiciously imposed *Now*. It is reserved to punish murderers of the most wanton and evil ilk.

Adios, Chess. You got a retrospectively raw deal. But don't shit a shitter, baby. I never bought that song and dance that you weren't the Red Light Bandit. The wages of sin are death. †

STATE OF CALIFORNIA

Department of Corrections

CALIFORNIA STATE PRISON
SAN QUENTIN, CALIFORNIA

———

F. R. DICKSON, WARDEN

ADDRESS ALL CORRESPONDENCE
TO THE WARDEN

ATTENTION OF:

February 5, 1960

PLEASE REFER TO
FILE No.

A27012A – CASH
66565B – CHESSMAN

D. W. Grant
c/o J. Miller Leavy
101 S. Grevillea Avenue
Inglewood, 1, California

Friday, February 19, 1960, at ten o'clock A.M., is
the date set for the execution of Donald Leonard
Cash, A-27012A and Caryl Chessman, 66565B, condemned
inmates of this institution.

If you desire to be a witness, please present this
notice at the prison gate not later than nine
o'clock A.M. on that date. No cameras, tape record-
ers or other devices are permitted.

In the event of any change in the scheduled date,
this notification will be void.

F. R. DICKSON, Warden

By: W. D. Achuff
Associate Warden

WDA:om

HATS

Clarence "Red" Stromwall. Max Herman. Eddie Benson. Harry Crowder.

Check their youthful I.D. photos.

Add some years, some pounds, some gravitas, some heft. Add four white fedoras—straw for warm weather, felt for winter days. You've got LAPD's legendary "Hat Squad"—and Whiskey Bill Parker's "Command Presence" defined.

They worked Robbery from '49 to '62. Eddie Benson died from the Big "C" in '70. Red, Max and Harry went to law school, passed the bar exam and practiced law. Max became a criminal defense lawyer. Harry and Red both became Superior Court judges.

Robbery was LAPD's "Heavy Squad." They went after men with guns and notched up bandit killings. The minimum height requirement was 6′ 2″. The Hats all topped that tape. They walked tall, they spoke softly. They were sartorially splendid. They tended not to carry roscoes—because they fucked up the lines of their suits. They never tattled their own exploits, post-LAPD career. They pulled some wild-and-woolly shit and took it to their graves. Did Harry Crowder really dangle a suspect out of an upper-floor window at City Hall until he spilled the goods? What about the heist guy they dangled off the Harbor Freeway? They were strong-arm troubleshooters for Bill Parker—we know that. Robbery suspects who had heard the Hats were on their ass often preemptively turned themselves in. In our beloved *Then*, there was always the hard way and the easy way. The Hats were very bright guys and *nice* guys. They did not *enjoy* dispensing hurt. However, if the application of hurt was required . . .

1953.

Then.

Armed robbery.

Cops hiding in false-front refrigerators, waiting to ambush liquor store heisters. Max, Harry, Eddie and Red. They kept it zipped. They held their mud. They left us to ponder—and *yearn* for their tales. †

63"

6'

5'9"

5'6"

5'3"

L.A. POLICE D

A POLICE DE

3 9 8 2 A POL

HANSEN

He was LAPD's "Mr. Homicide."

The title held for '53, as well as for the decades immediately preceding and following.

He was a tall Bloodhound.

Sergeant Harry Hansen.

His career spanned the Jazz Age to the Sizzling Sixties. He sent husband-slayer Louise Peete to the green room. He was hard at work on the Joseph James Reposo/liquor store–heist snuff in our target year of '53. He was LAPD's lead investigator on the most celebrated unsolved murder case in American history.

The victim: Elizabeth Short.

Her moniker: the Black Dahlia.

The Boston girl, bound and hideously tortured. The severed body in the vacant lot at 39th and Norton.

Dylan Thomas wrote, "After the first death, there is no other."

Harry Hansen worked scores of deaths before and after Betty Short's. Betty Short was always the first last and death for him. He carried a photo of Betty in his wallet. He talked to her ghost and called her "Elizabeth." He worked lead after lead after lead, from the 1/15/47 inception of the case, up through his retirement and to the end of his life.

He chased every clue. He assessed every tip and heard out every nut-job theory. He always held that detectives had never talked to the killer. He remained fixated, he remained obsessed. He was a kind man with great good cheer for the world at large. He did not plummet down the deep, dark rabbit whole of obsession. He lived in equanimity and remained forever on task.

He was not the vindictive psycho cop we dig from film noir. He did not carry a necrophile torch for Betty Short. He loved her in an impersonal way commensurate with his assignment of task. Betty Short. The Black Dahlia. Crazy tips still flood the LAPD switchboard—*Then* to *Now*. Betty Short and Harry Hansen, heavenly reunited. They know how Betty fell.

No earthly human being shares that ghastly secret! †

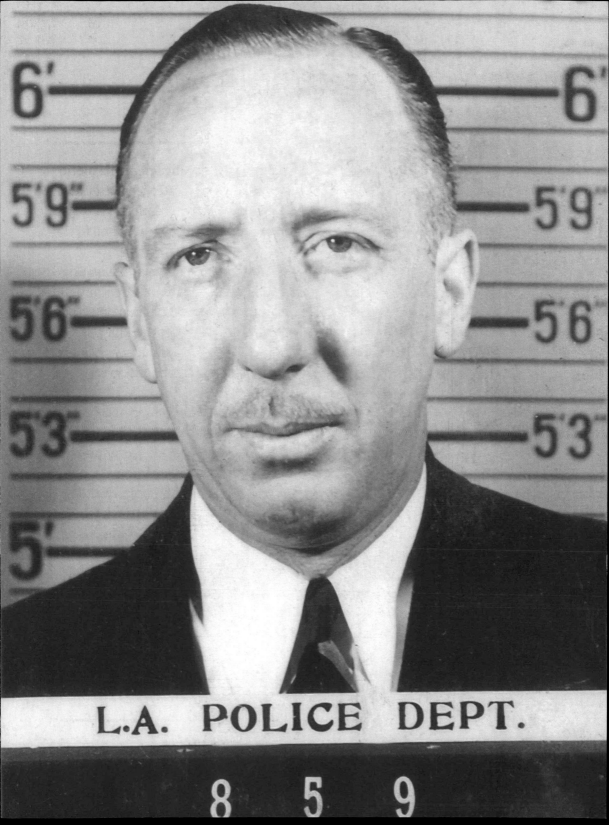

6' — 6'

5'9" — 5'9"

5'6" — 5'6"

5'3" — 5'3"

5' — 5'

L.A. POLICE DEPT.

8 5 9

THAD

He was almost Chief.

He was destined to be Chief.

He was as even-tempered and friendly as Bill Parker was volatile and remote. He missed out on the big job by a quirk of fate off a rat's pubic hair margin. He was a great detective, while Bill Parker never worked a Detective Division assignment. He became the interim Chief following Parker's death and held the reins for future Chief Tom Reddin. Ladies, gentlemen and knocked-out numbskull hipsters buying this book in droves—Thad Brown!!!!!

He worked his way up through the ranks during the coruscatingly corrupt pre-Parker era. Policeman, Sergeant, Lieutenant, Captain, Inspector, Deputy Chief. Great anti-sabotage work during World War II.

The Brenda Allen vice scandal topples Chief C. B. Horrall. Retired Marine Corps Major General William Worton holds the reins until a new Chief can be appointed, on the basis of civil service exams and a Police Commission vote. General Worton does a crackerjack job as gatekeeper. Brown scores number one on the oral exam. Parker bests him on the written exam. Thad's got the commission votes, he's a shoo-in, it's a lock—but a Commissioner drops dead of a heart attack the day before the vote. The job goes to Whiskey Bill.

How many times have I said this?

It's Whiskey Bill Parker's town—we just live in it.

The great Parker reforms the LAPD. Thad Brown is his Chief of Detectives. Thad's his main man, his confidential consigliere, his *ichiban*. Thad presides over the stunningly potent LAPD Detective Bureau of 1950 to 1966.

Interdiction.

Suppression.

Those were Parker's concepts. The Comprehensive Police Investigation was Thad's *métier*. Parker and Brown—American law enforcement's greatest one-two punch. †

TOM

Mayor Tom.

Here's something you history-phobic hipsters don't know.

Tom Bradley, L.A.'s longest-serving mayor, was once Lieutenant Tom Bradley, LAPD.

He was Tom "Schoolboy" Bradley when he came on in '40. It was a less-enlightened era—and Schoolboy Tom got the racial runaround before he was reluctantly admitted to the Police Academy. Schoolboy Tom—the transcendent track star from UCLA. Bradley was an Academy classmate of future Chief Ed Davis. The LAPD badge went from the eagle-top design to the familiar oval shield that year.

Bradley rose to brass-hat status, went to law school part-time and studied for the bar exam during his lag time as the night-watch boss at Wilshire Station.

He was an astute, ambitious policeman-lawyer or lawyer-policeman—take your pick. He exemplified LAPD's reluctant inclusiveness, even in the pre-Parker era. Lieutenant Tom, Mayor Tom. He honed his deft social skills on the street. Bill Parker disliked him. It wasn't racial rancor. The two men were simply too much alike.

Tom Bradley—Big City Cop.

Tom Bradley—Big City Mayor! †

CENTRAL
DIV

Central Station (1896–1955)
located at 314 West 1st Street

174608
10-2-53
H.G.W.

CITY JAIL
NE 6

SHINE BOOTS 5¢
SAM BROWNE 5¢
GET CHIT AT DESK

JAMES ELLROY

AFTERWORD

THIS BOOK WAS BOTH A LABOR OF LOVE AND A STONE GAS TO ASSEMBLE AND WRITE. YOU COULD TELL, COULDN'T YOU?

The work went down at the Los Angeles Police Museum—the LAPD's former Northeast Station, in the former Mexican gang turf/current hipster hive of Highland Park. Glynn Martin spearheaded the effort. Joan Renner, Nathan Marsak, Mike Frantantoni, and Megan Martin put together the stunning photographs. These kats are the Museum's most inspired volunteers; they brought a deep love for L.A. Then to their collating task. They supplied me with brilliantly concise crib sheets. Said sheets inspired my accompanying captions. All of us concocted the 1953-photographs-only concept. It stands as the book's defining construction.

Some concept.

Some year.

I wish *Then* were *Now*.

Where's William H. Parker now that we really need him?

Demonic humor infused our work sessions. Why mince words, or mince at all? Glynn was born into kop komedy—while Joan, Nathan, Meg, and I came at it sideways. Los Angeles cops are the greatest oral historians and bullshit artists in world annals, and *LAPD '53* is fully intended to express the right-wing absurdist world-view that so often informs their stories. Death and yuks a heartbeat apart. You've gotta look and you've gotta laff.

756
5-58-JW.

America's greatest police department has always been America's most pictorially depicted and dramatically portrayed police department. We can thank the proximity of the Hollywood film studios and the reign of film noir for that. This means that thanks are also due to André De Toth, Billy Wilder, Sterling Hayden, Lizabeth Scott, Robert Aldrich, John Alton, and numerous other denizens of the deep-focus deep. Among our creative antecedents, special nite howls go out to Joseph Wambaugh, the creator of the modern police novel, and Jack Webb, television's first great auteur—and the most generous friend and civilian supporter the LAPD has ever known.

David Cashion and Deborah Aaronson of Abrams Image are the Wambaugh and Webb of this generation. *LAPD '53* is a rugged tome for the wrapped-tight and raucously reactionary. David and Deborah provided adroit advice and guidance every step of the way—even as I'm sure they were cringing. They should receive special Get-Out-Of-Jail and Frame-Your-Publishing-Enemies cards from LAPD—signed by all of us who worked on this book.

James Ellroy
1/5/15

THE *Los Angeles Police* BEAT

December 1953

ACKNOWLEDGEMENTS

The images that appear herein were made during one of LA's growth spurts. Some of the crimes depicted are quite unique, while others have seemingly played out at other times and in different places. Still, the constants are two: those who suffered—victims and their loved ones—and those who were charged with responding to and investigating the crimes. From the photographic intersection of these worlds emerges sympathy for the victims and gratitude for those who have served—and those that continue to serve—the LAPD.

The stories might not coincide exactly with what actually occurred. Such is the mandate of historical fiction. Accordingly, the treatments as they are spelled out may not strike the fancies of each and every reader. Realize that crime stories typically aren't intended for the whole family. Hope will remain that the words and photos lend perspective to an LA in mid-century transition.

Some of the photography qualitatively surpasses that of typical crime scene imagery. Those who snapped the pictures receive this acknowledgment for their talent and commitment. Many of the policemen responsible for the images have passed; what remains is their unseen work that can now be interpreted and admired.

So, too, can the words of bestselling author James Ellroy. His unequivocal support of the LAPD brought him to the Los Angeles Police Museum a decade ago. His philanthropy and popularity have assisted the police museum for most of its existence. Simply put: The evolution experienced by the Los Angeles Police Museum was frequently facilitated by Ellroy. His generosity and creativity fueled the museum's growth in many dimensions. It is an honor to have an author of his standing and his abilities driving interest in the Museum and its programs.

There is no other like-situated museum whose partner is as talented or accomplished.

James—Thank you and Godspeed!

Glynn Martin
1/6/15

THE GLOSSARY

211 P.C. The section of the California Penal Code for the crime of robbery.

459 The section of the California Penal Code for the crime of burglary.

APB All Points Bulletin.

ARROYO SECO A dry streambed that runs through Los Angeles. L.A.'s first freeway was built alongside the Arroyo Seco in 1940. The term also refers to the neighborhoods that border the inactive stream.

BIG "H" Heroin.

BILTMORE HOTEL A landmark in downtown Los Angeles. When opened in 1923, it was the largest hotel west of Chicago. It gained fame in 1947 as the last location Elizabeth Short (the Black Dahlia) was seen alive.

BOYLE HEIGHTS A racially diverse area of Los Angeles immediately north and east of the center of the city. Also considered part of East Los Angeles.

BUNKER HILL A section of Los Angeles on the western border of downtown.

CHINO A reference to the state prison located in this California city.

CLUB ALABAM A nightclub in South Central Los Angeles.

CLUB ZOMBIE A nightclub in South Central Los Angeles known for jazz music

DAILY BULLETIN A publication of the LAPD that was distributed to officers at the start of their watch. The bulletin contained a variety of information including wanted persons, new regulations, stolen vehicles and more.

DRAGNET Originally a radio series based on fictional LAPD officers. It became a popular television series in the 1950s and '60s. Jack Webb directed, produced and starred in the program, which helped popularize the LAPD. Two motion pictures and a series of paperback books of the same name were also produced.

GEORDIE HORMEL Grandson of the Hormel foods corporation founder. Known for his musical compositions, especially television themes, and as the founder and proprietor of Village Recording Studio.

GLASSELL PARK An area of Los Angeles bordering the city of Glendale and adjacent to the Golden State Freeway and the L.A. River.

——————— Cont'd

GREEN ROOM The chamber in which California executions were carried out.

JUNKIE A drug addict.

LAPD The Los Angeles Police Department, which in 1953 consisted of 12 stations—Central, University, Hollenbeck, Harbor, Hollywood, Wilshire, West Los Angeles, Valley, Highland Park, 77th Street, Newton and Venice.

L.A. RIVER The Los Angeles River, a once free-flowing river that now runs through a 48-mile concrete channel from the Santa Susana Mountains to its terminus in Long Beach.

LAUREL CANYON A Los Angeles neighborhood on the western edge of Hollywood

THE ONION FIELD A book and movie written by LAPD Sergeant Joseph Wambaugh detailing the kidnapping of LAPD Officers Ian Campbell and Karl Hettinger. Campbell was shot and killed in an onion field 90 miles north of Los Angeles. Hettinger survived, but spent his life emotionally scarred by the events.

PACOIMA An area of Los Angeles in the east San Fernando Valley.

RED DEVILS Street vernacular for a barbiturate in a red capsule.

SAN QUENTIN A California state prison that opened in 1852 and houses condemned prisoners.

SPIKE A hypodermic needle, syringe.

VALLEY RECEIVING HOSPITAL The LAPD once administered a hospital system, which was partially serviced by ambulances dispatched from police stations. The hospitals were located adjacent to many LAPD stations and staffed by doctors and nurses employed by the LAPD.

WILLIAM H. PARKER Chief of the LAPD from 1950 to 1966, who is credited with reforming the department during that period. Parker was an attorney and a former Army officer wounded during the D-Day invasion. He was renowned the world over as a law enforcement leader and consulted with many foreign nations about forming and professionalizing civilian police forces.

YELLOW JACKETS Street vernacular for a barbiturate in a yellow capsule.

1953

SUN	MON	TUES	W
/	/	1	2
6	7	8	9
13	14	15	1
20	21	22	2
27	28	29	3